ORNAMENTAL FORMS FROM NATURE

EDITED BY CHRISTIAN STOLL

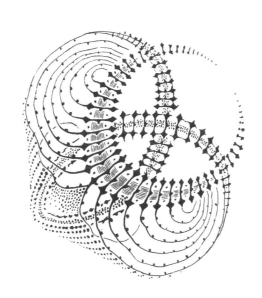

DOVER PUBLICATIONS, INC.
MINEOLA, NEW YORK

Planet Friendly Publishing
✔ Made in the United States
✔ Printed on Recycled Paper
Learn more at www.greenedition.org

GREEN EDITION

At Dover Publications we're committed to producing books in an earth-friendly manner and to helping our customers make greener choices.

Manufacturing books in the United States ensures compliance with strict environmental laws and eliminates the need for international freight shipping, a major contributor to global air pollution.

And printing on recycled paper helps minimize our consumption of trees, water and fossil fuels. The text and cover of *Ornamental Forms From Nature* was printed on paper made with 10% post-consumer waste. According to Environmental Defense's Paper Calculator, by using this innovative paper instead of conventional papers, we achieved the following environmental benefits:

Trees Saved: 9 • Air Emissions Eliminated: 946 pounds
Water Saved: 3,104 gallons • Solid Waste Eliminated: 513 pounds

For more information on our environmental practices, please visit us online at www.doverpublications.com/green

Copyright

Copyright © 2009 by Dover Publications, Inc.
Electronic images copyright © 2009 by Dover Publications, Inc.
All rights reserved.

Bibliographical Note

This Dover edition, first published in 2009, contains a new selection of images from *Ornamentale Zierformen nach der Natur*, originally published by Verlag von Christian Stoll, c. 1910.

DOVER *Pictorial Archive* SERIES

This book belongs to the Dover Pictorial Archive Series. You may use the designs and illustrations for graphics and crafts applications, free and without special permission, provided that you include no more than ten in the same publication or project. (For permission for additional use, please write to Permissions Department, Dover Publications, Inc., 31 East 2nd Street, Mineola, N.Y. 11501.)

However, republication or reproduction of any illustration by any other graphic service, whether it be in a book or in any other design resource, is strictly prohibited.

International Standard Book Number
ISBN-13: 978-0-486-46888-4
ISBN-10: 0-486-46888-7

Manufactured in the United States of America
Dover Publications, Inc., 31 East 2nd Street, Mineola, N.Y. 11501

For technical support, contact:
 Telephone: 1 (617) 249-0245
 Fax: 1 (617) 249-0245
 Email: dover@artimaging.com
 Internet: **http://www.dovertechsupport.com**
 The fastest way to receive technical support is via
email or the Internet

NOTE

The incredible designs in this collection are straight from nature. The beautifully detailed images include an array of plant and animal life from the sea and on land. They have been repeated, combined and arranged artistically to show you a wide range of creative possibilities.

Taken from a rare, early-twentieth-century German portfolio, these designs are a source of inspiration for designers and craftspeople. The accompanying CD-ROM features both high- and low-resolution color JPEG files of each spread, exactly as shown in the book and high- and low-resolution grayscale JPEG files of each individual motif.

The "Images" folder on the CD contains four folders. All of the high-resolution color files have been placed one folder, as have all of the Internet-ready color files, all of the high-resolution grayscale files, and Internet-ready grayscale files. Every image has a unique file name in the following format: xxx.JPG. The first 3 digits of the file name, before the period, correspond to the number printed under the image in the book. The last 3 letters of the file name "JPG," refer to the file format. So, 001.JPG would be the first file in the folder.

Also included on the CD-ROM is Dover Design Manager, a simple graphics editing program for Windows that will allow you to view, print, crop, and rotate the images.

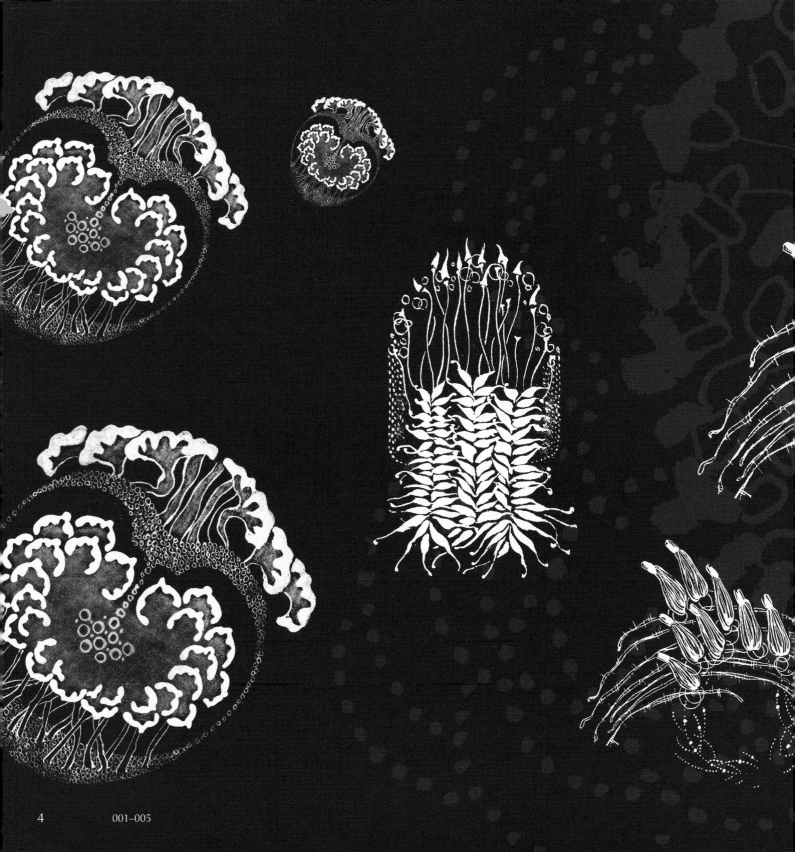

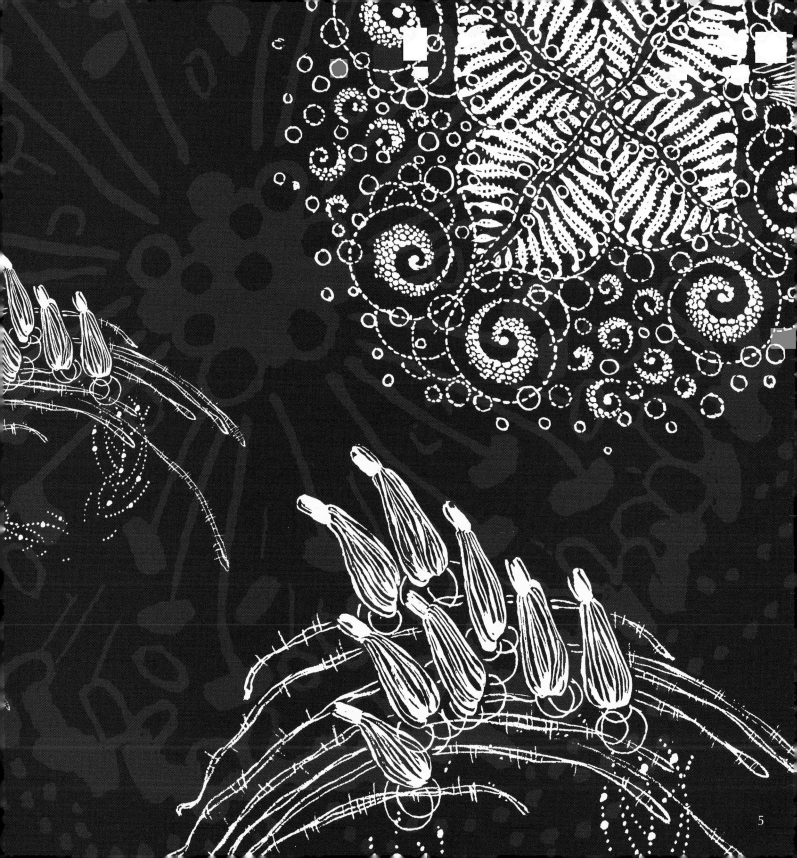

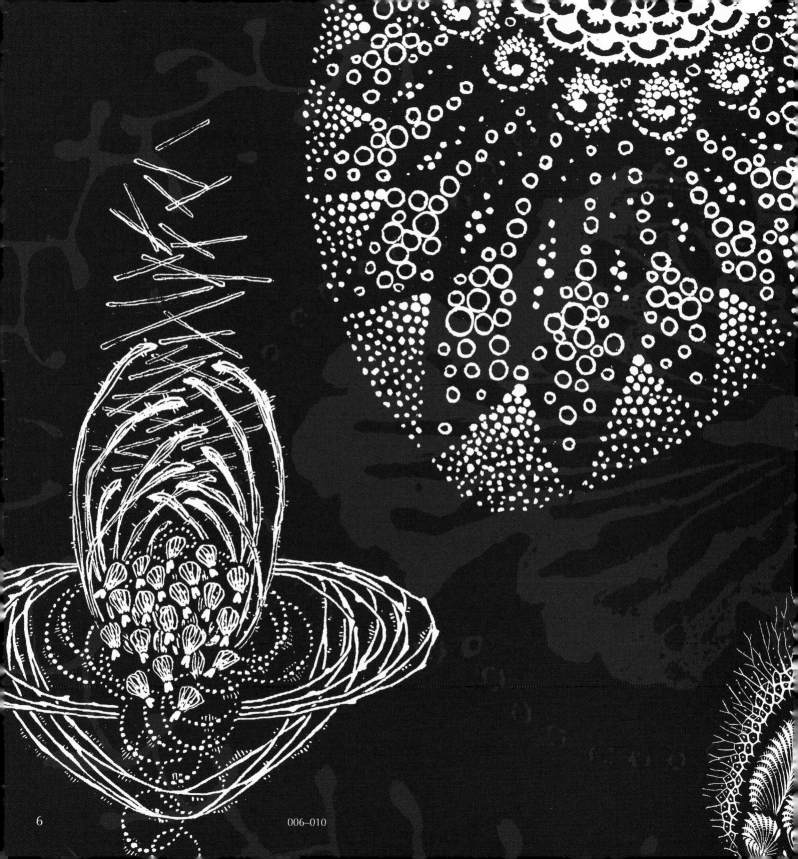

006–010

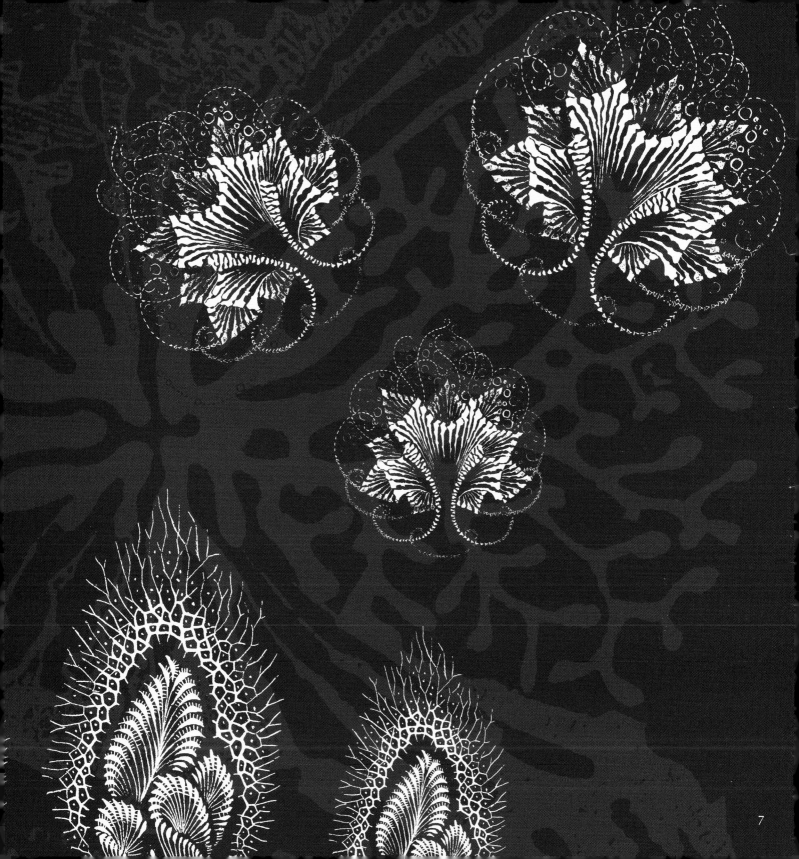

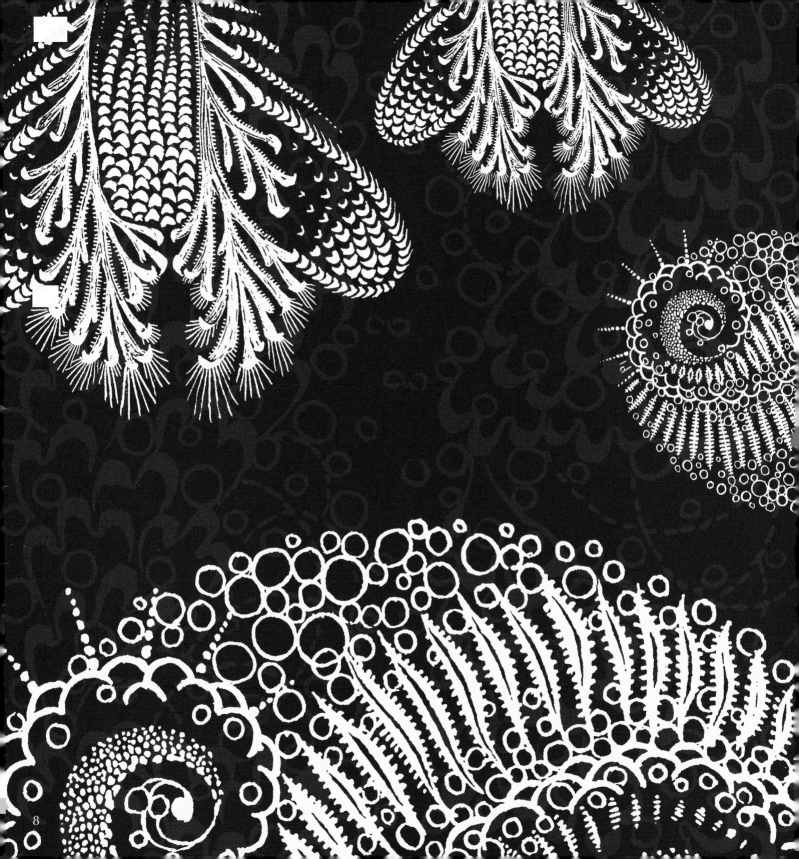

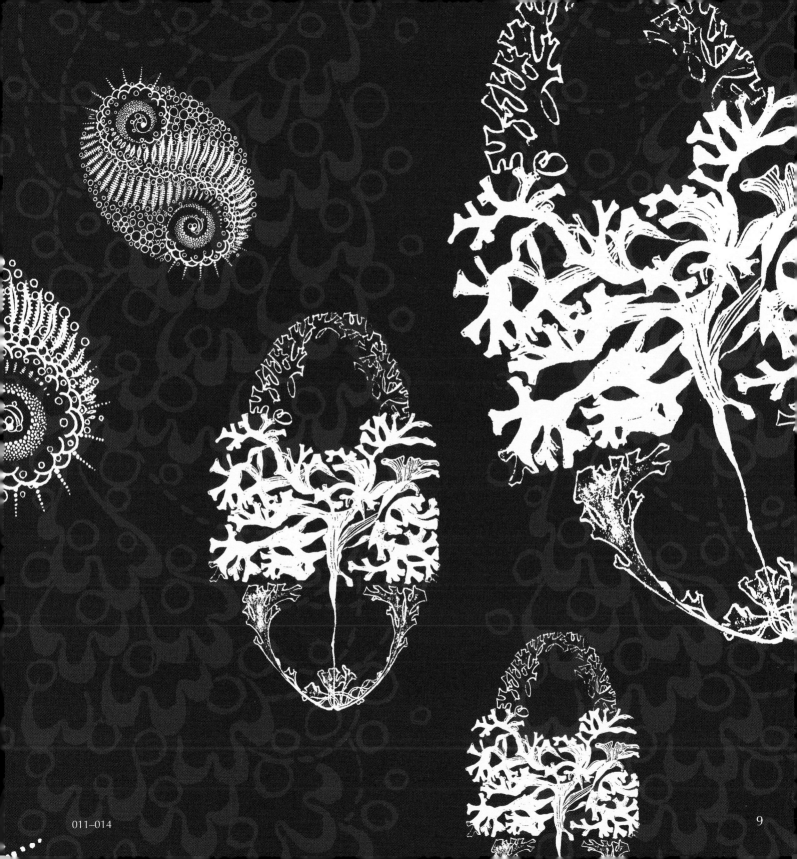

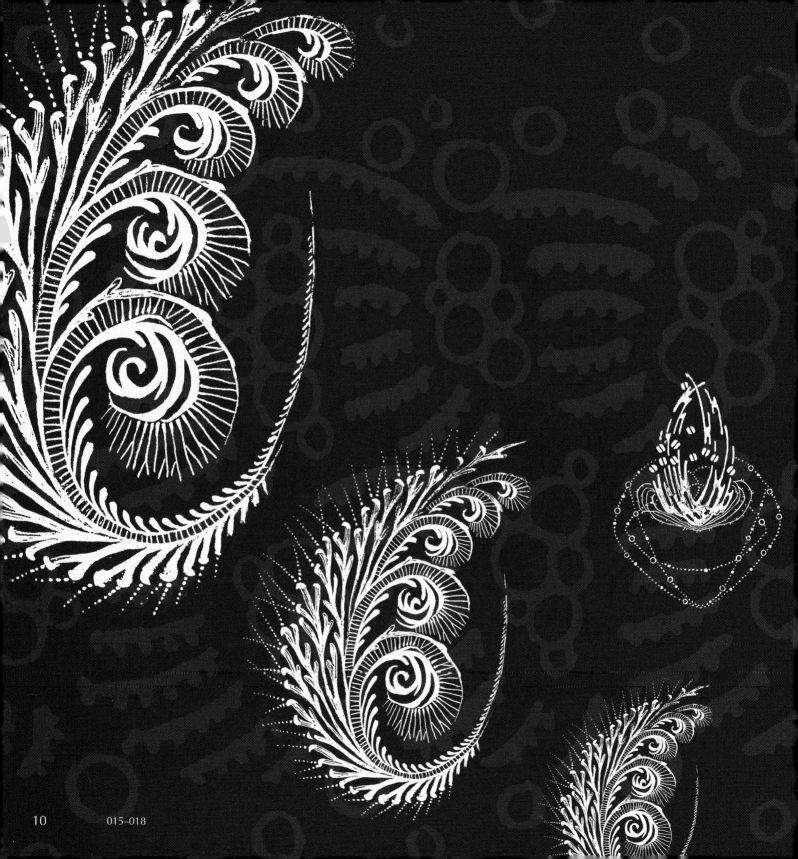

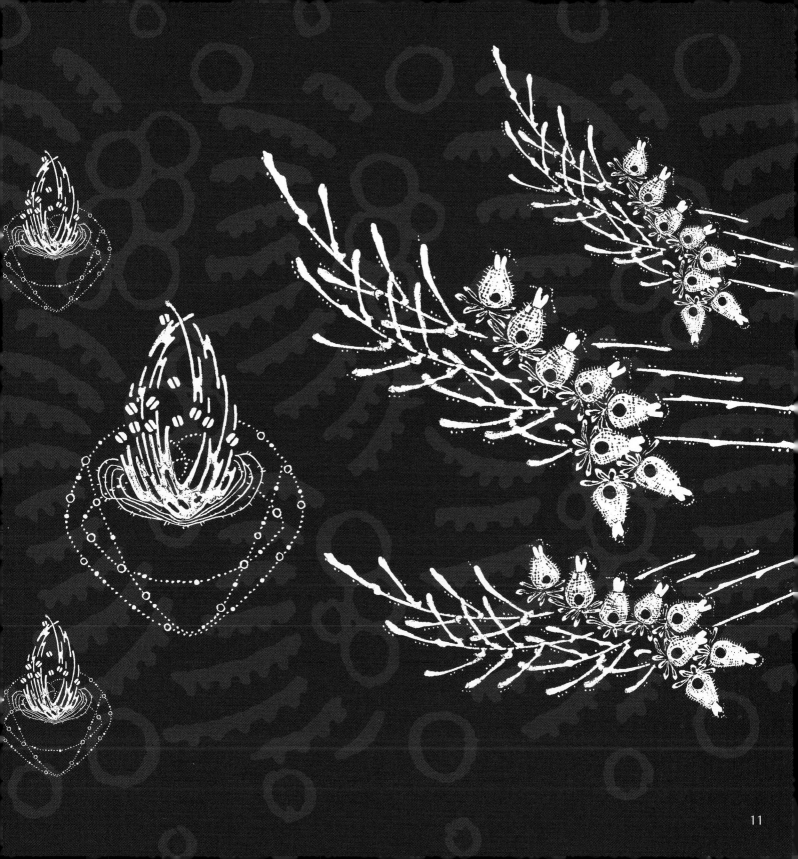

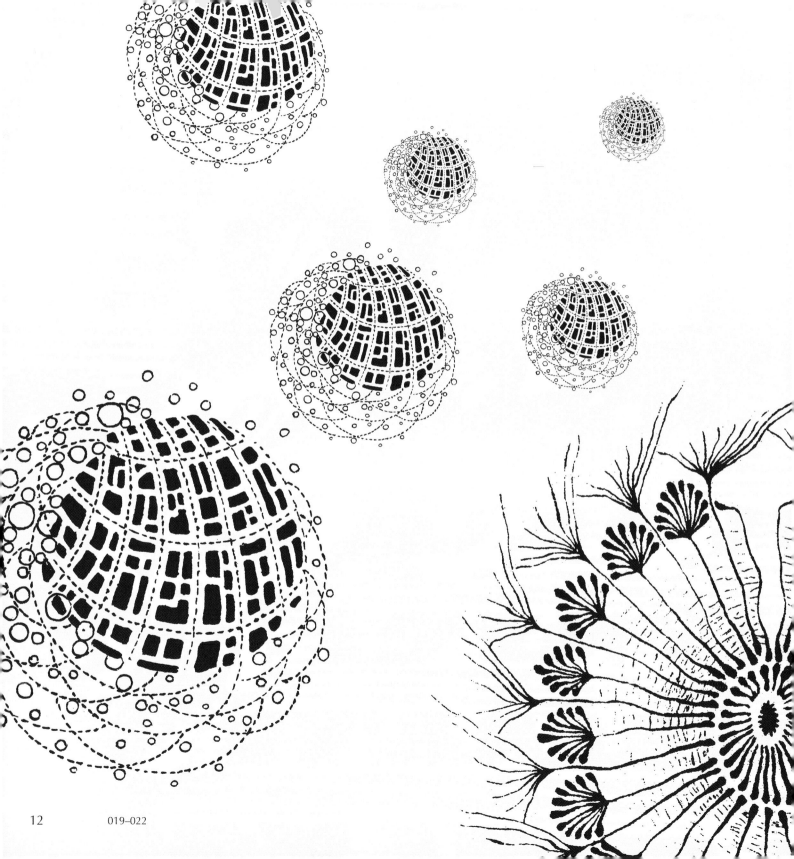

019–022

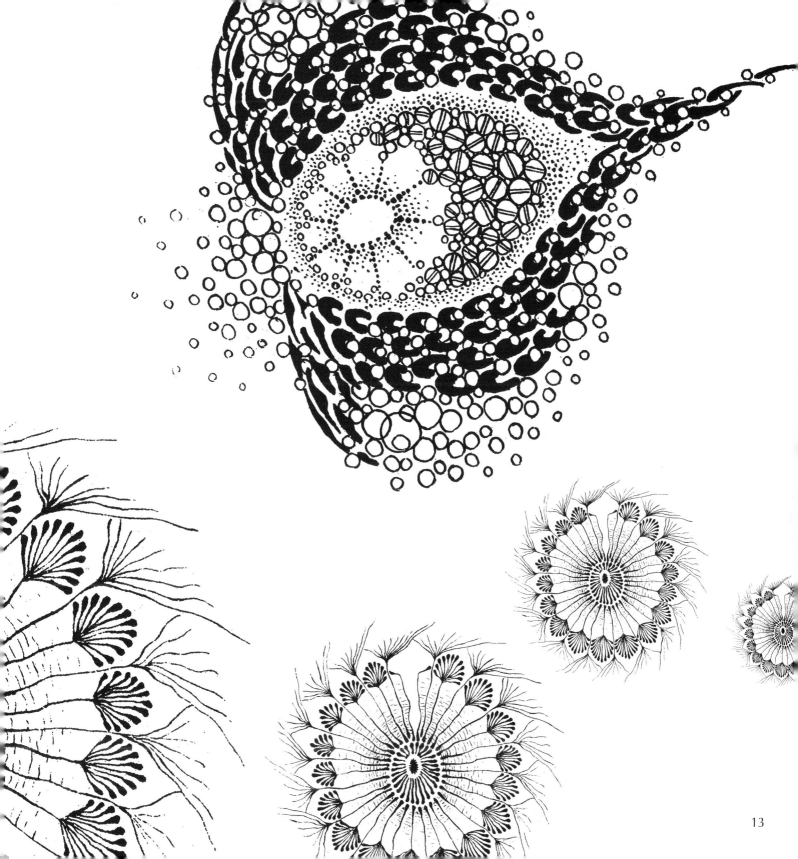

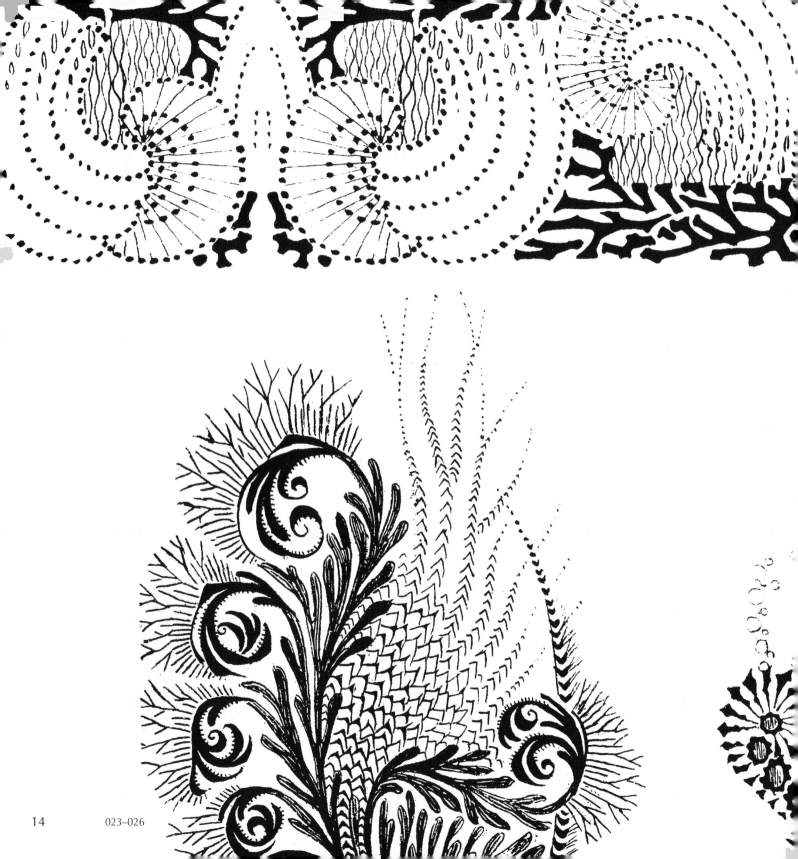

023–026

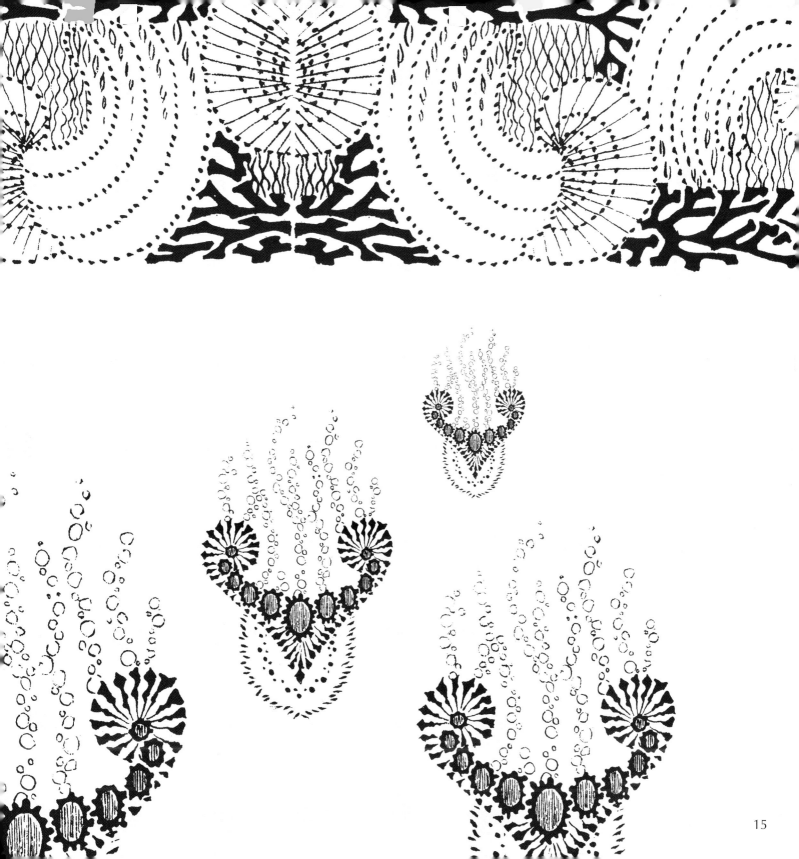

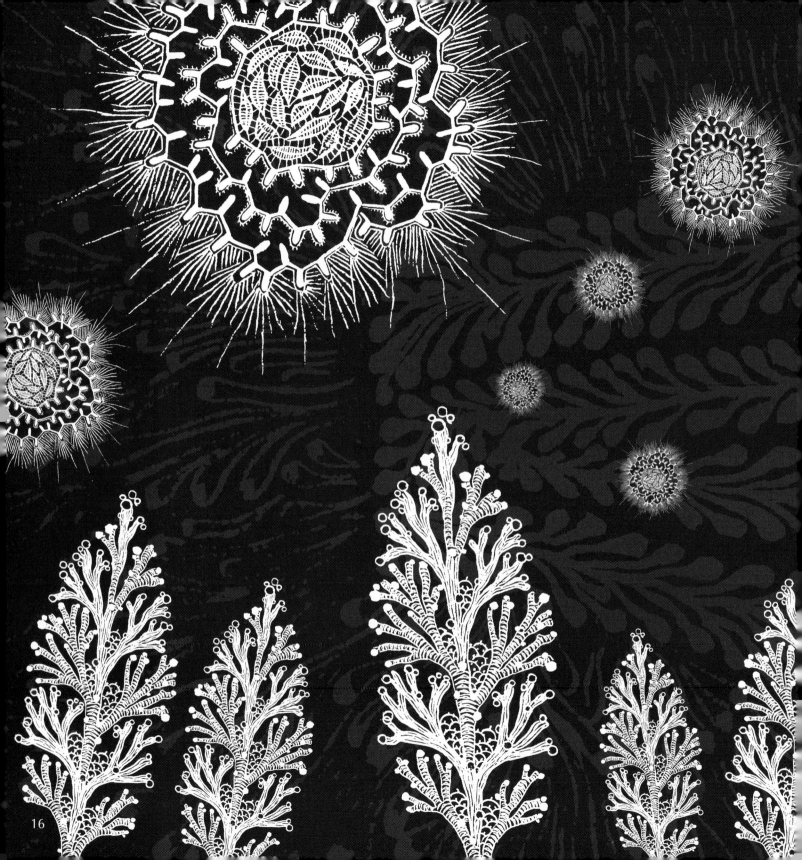

16

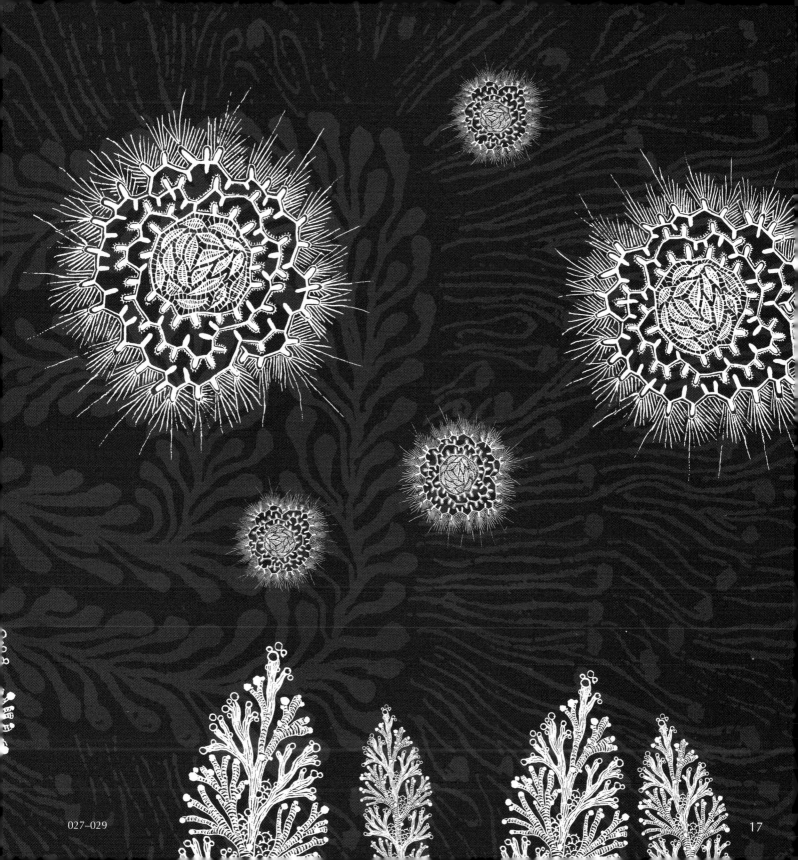

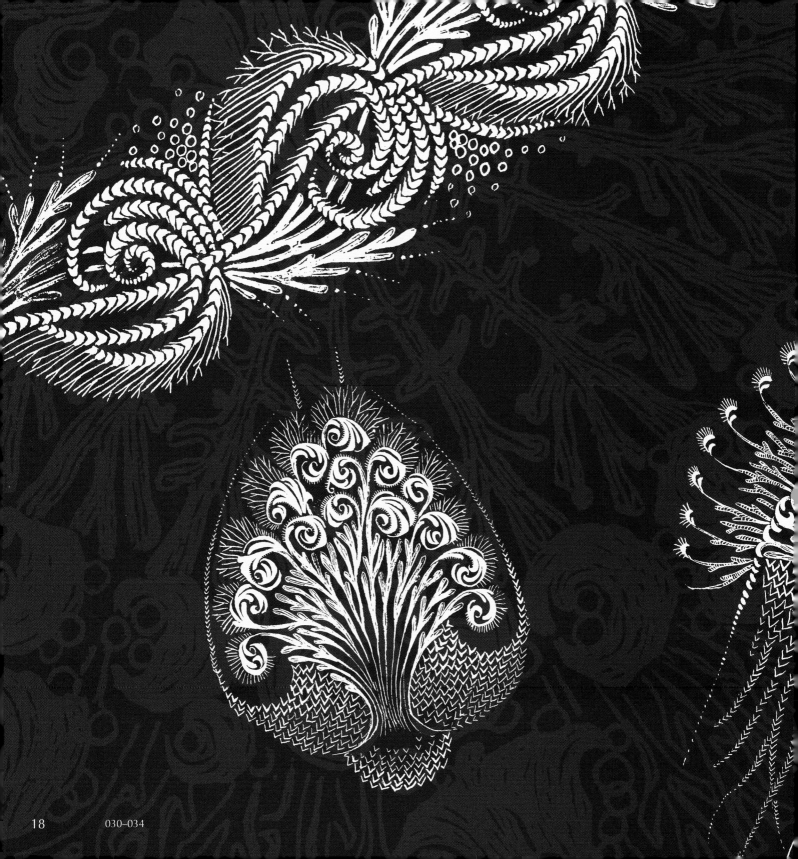

030–034

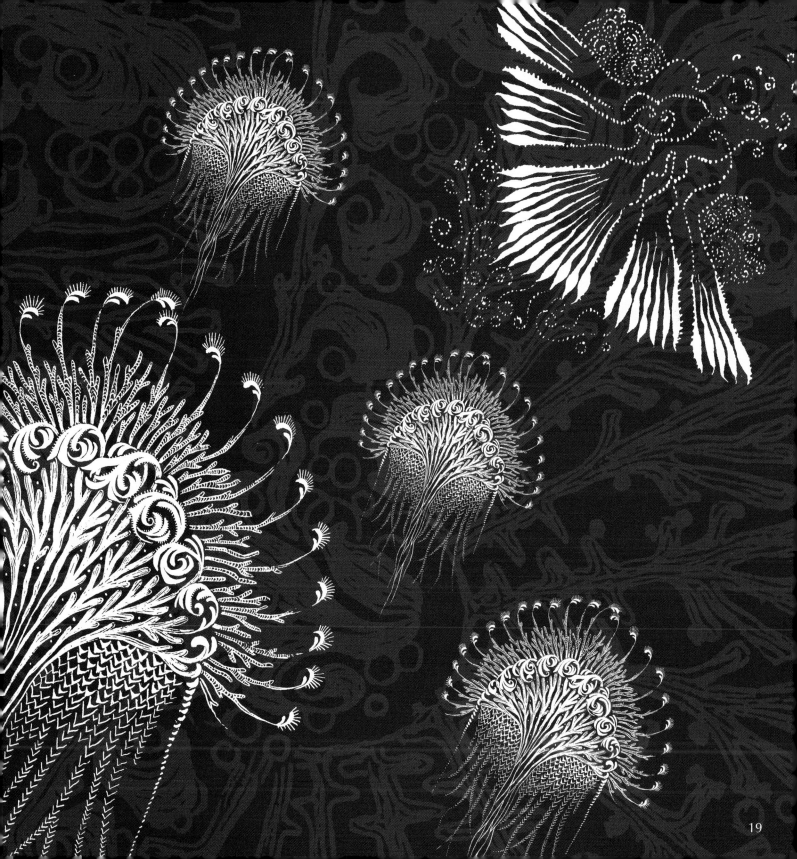

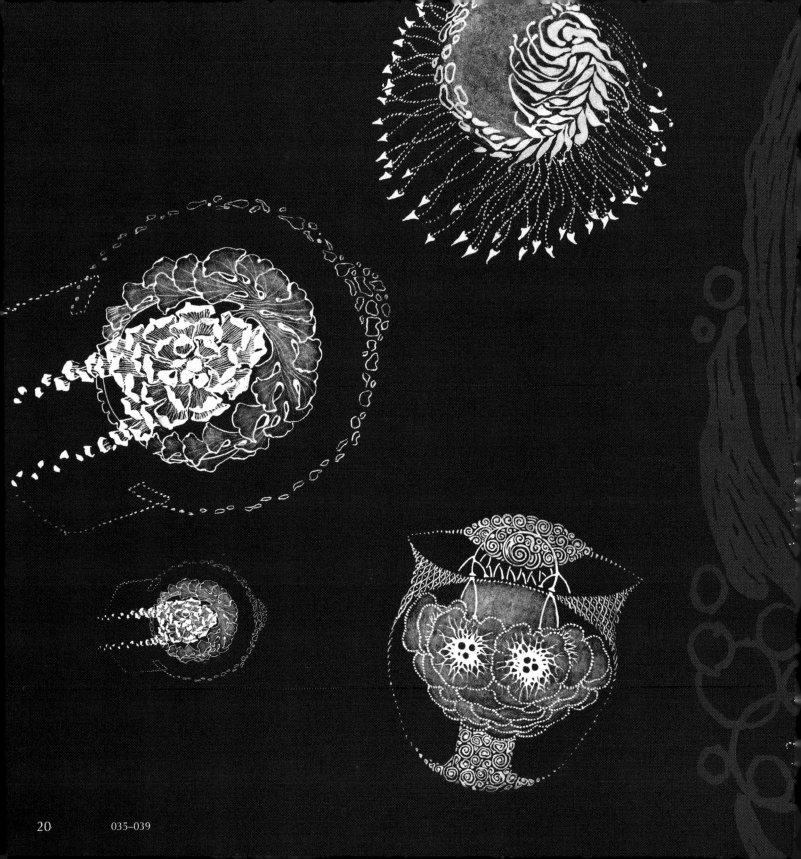

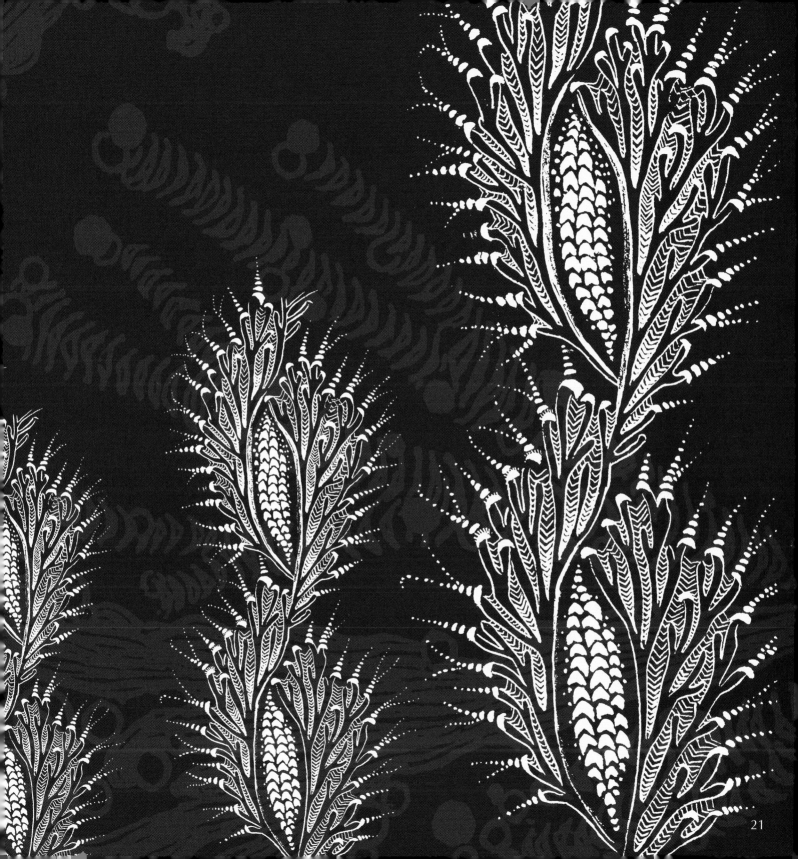

21

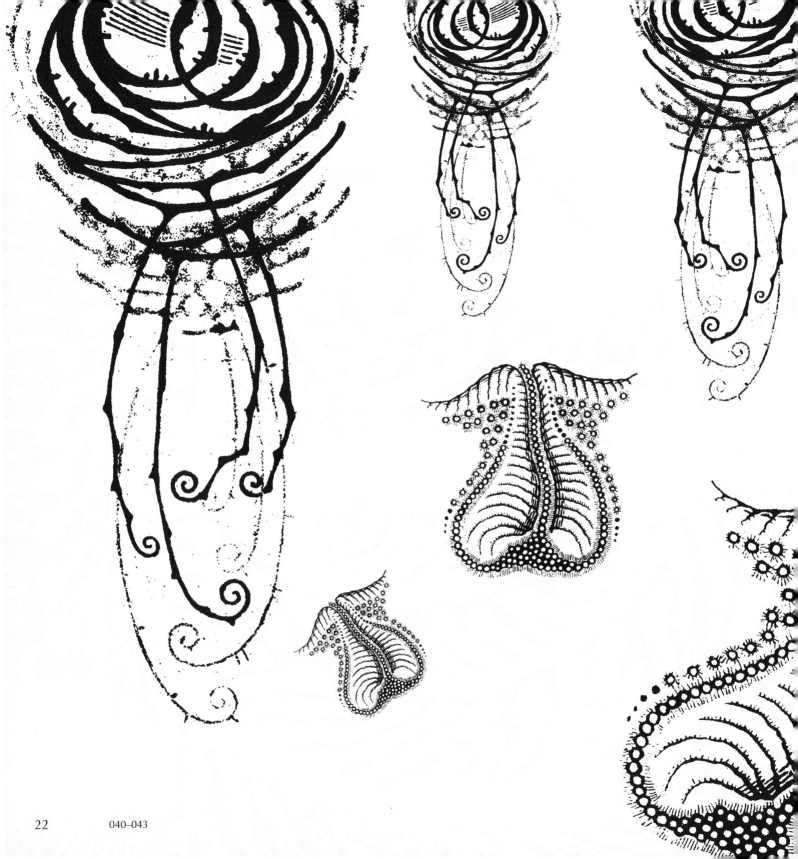

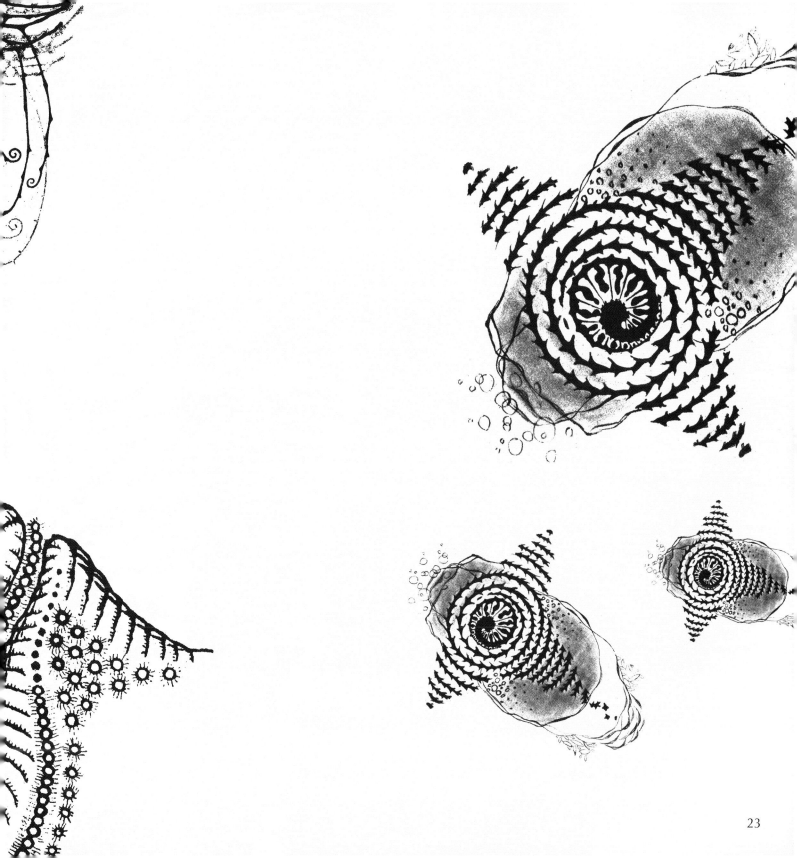

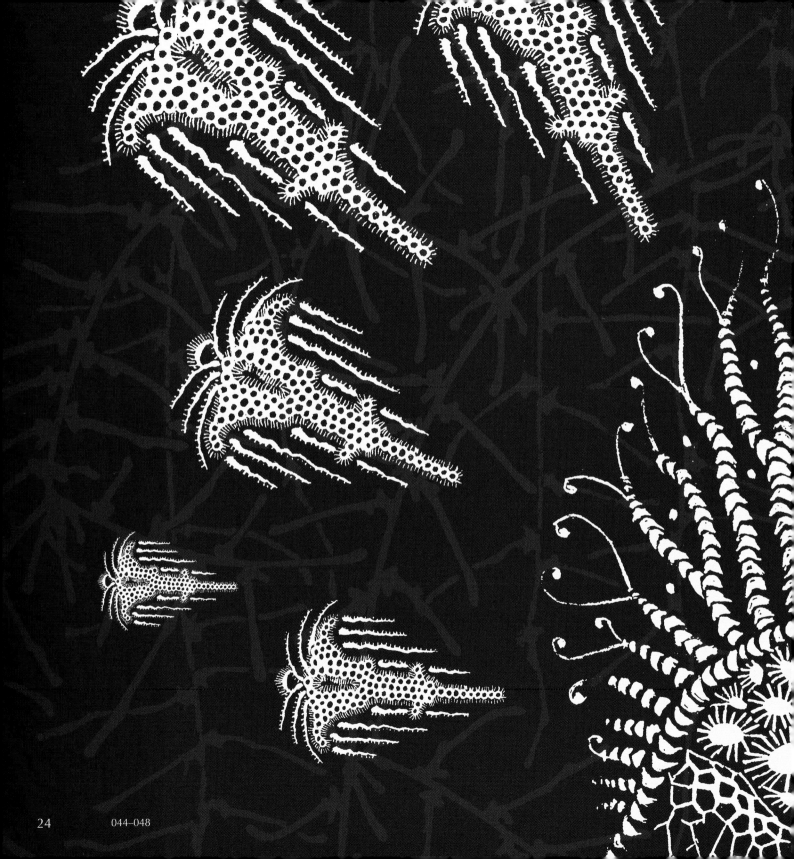

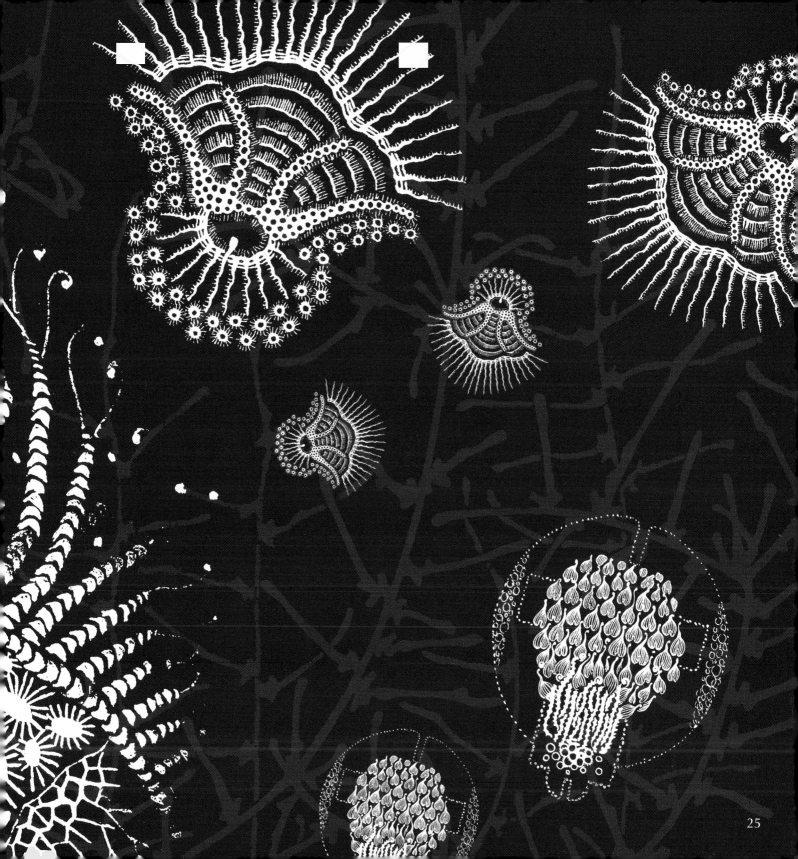

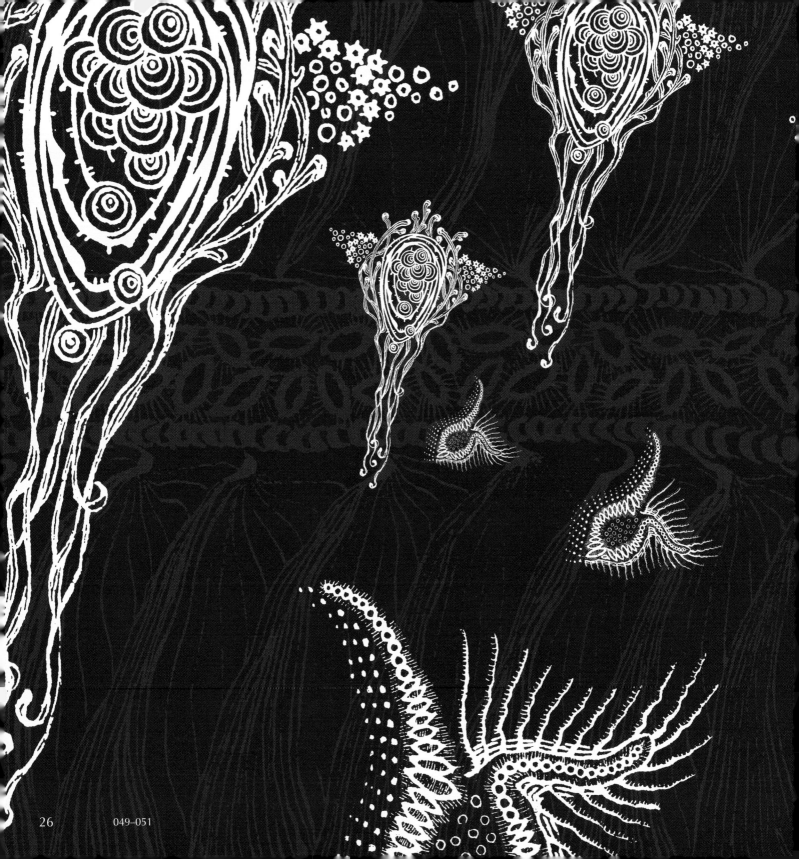

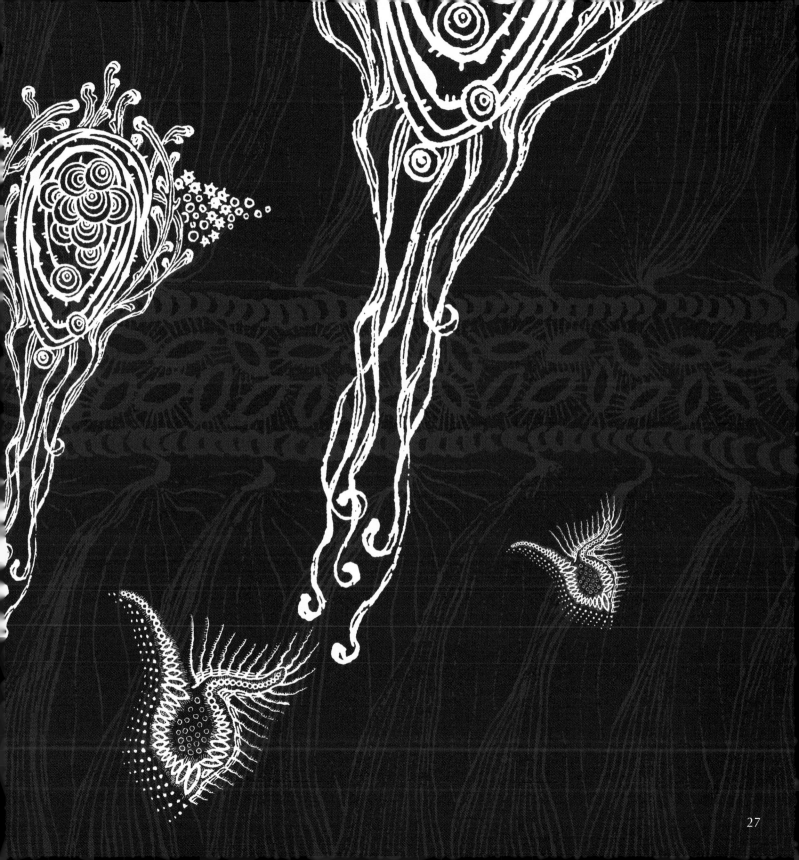

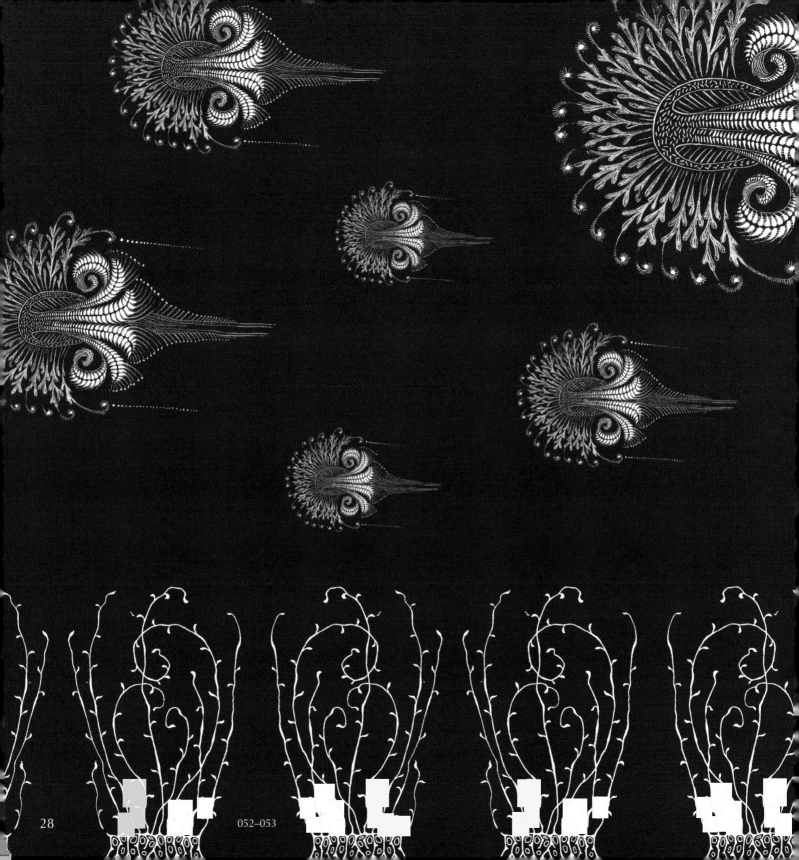

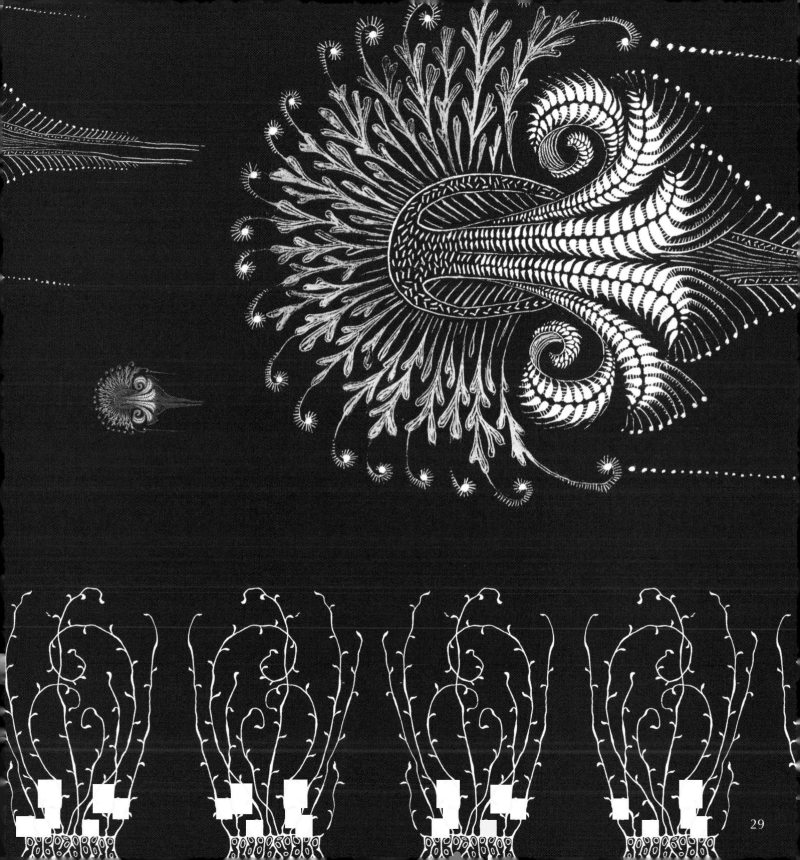

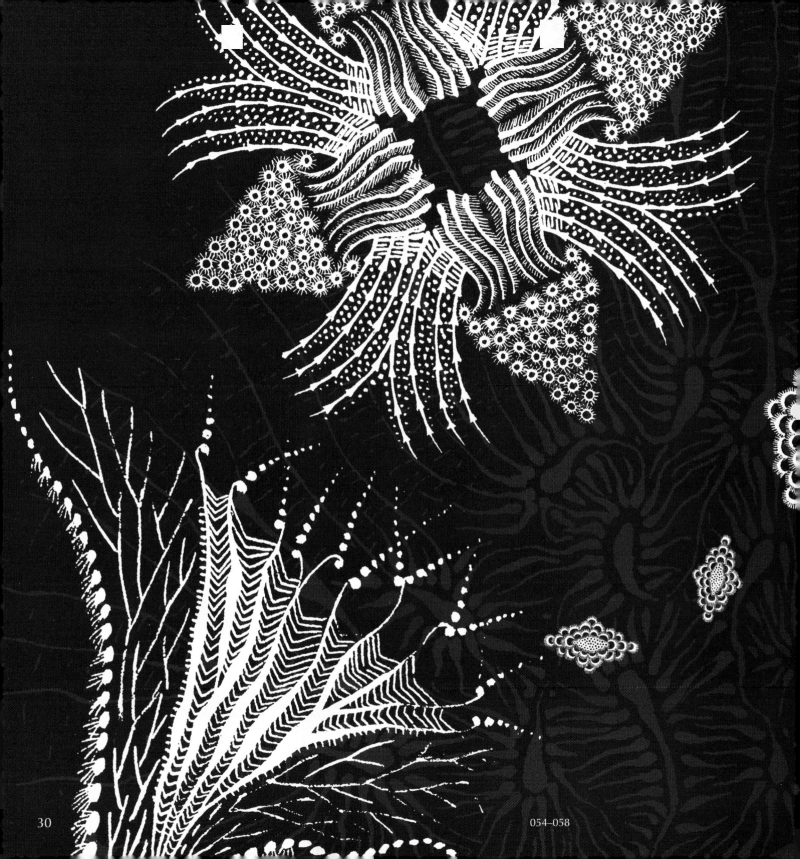

054–058

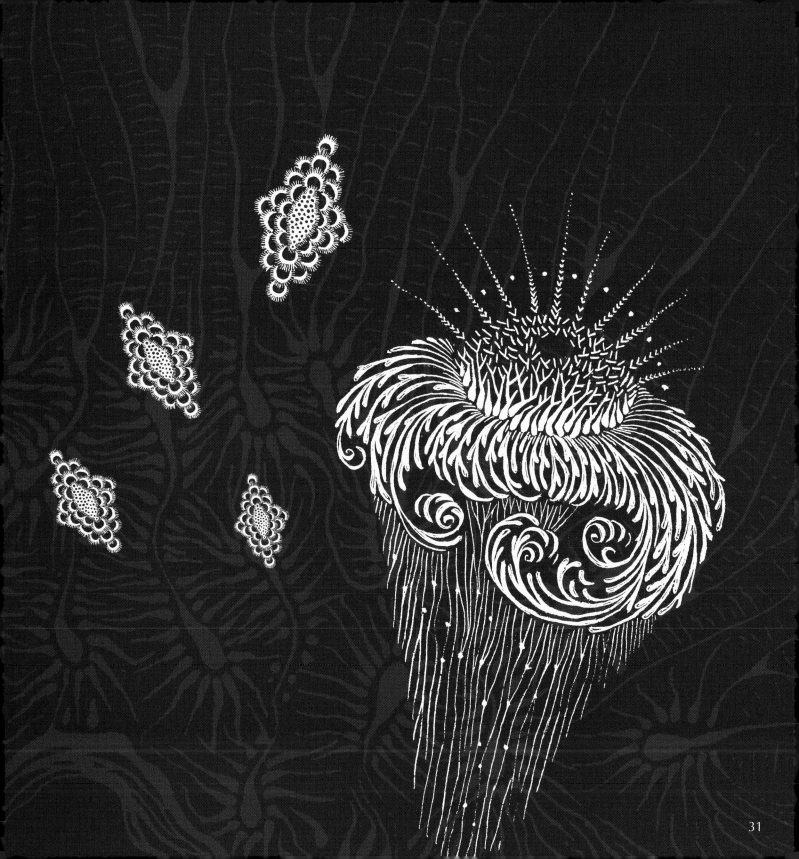

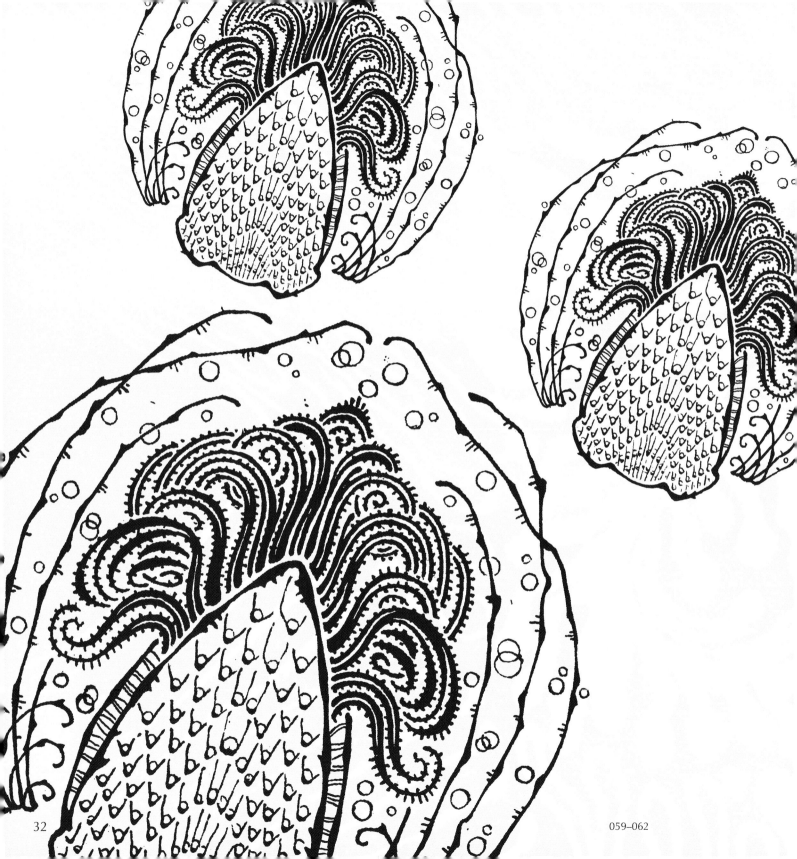

32

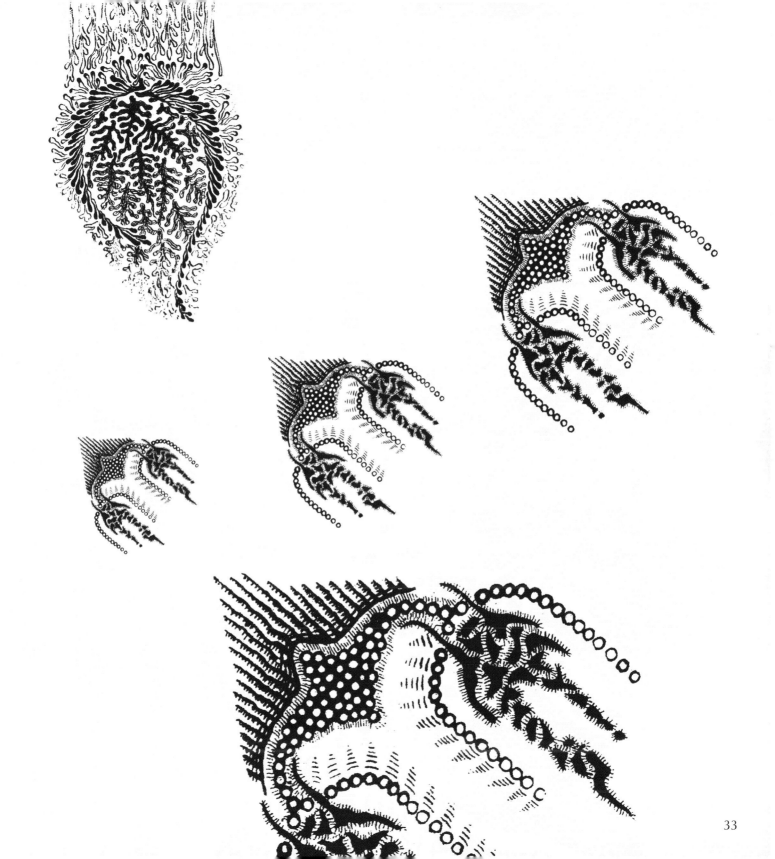

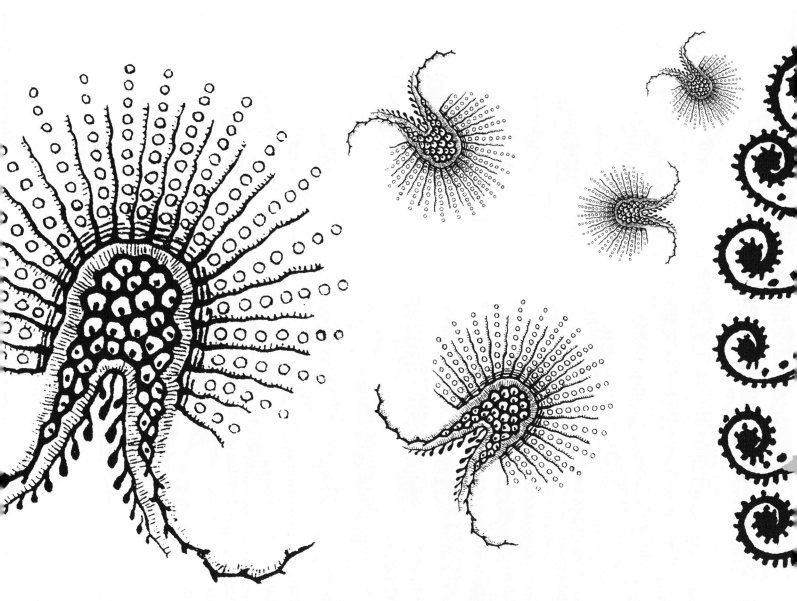

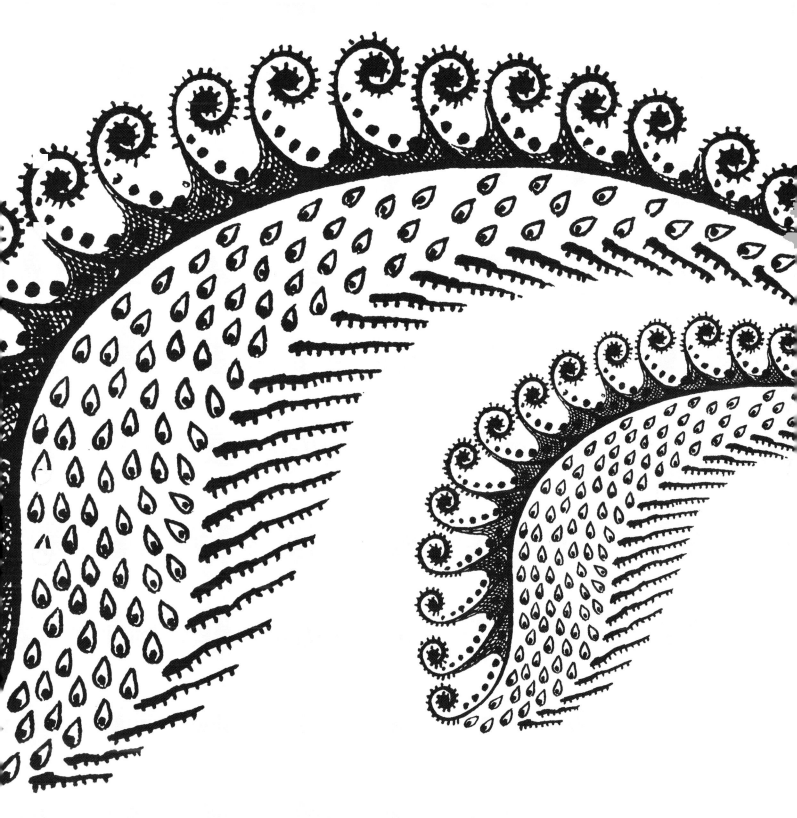

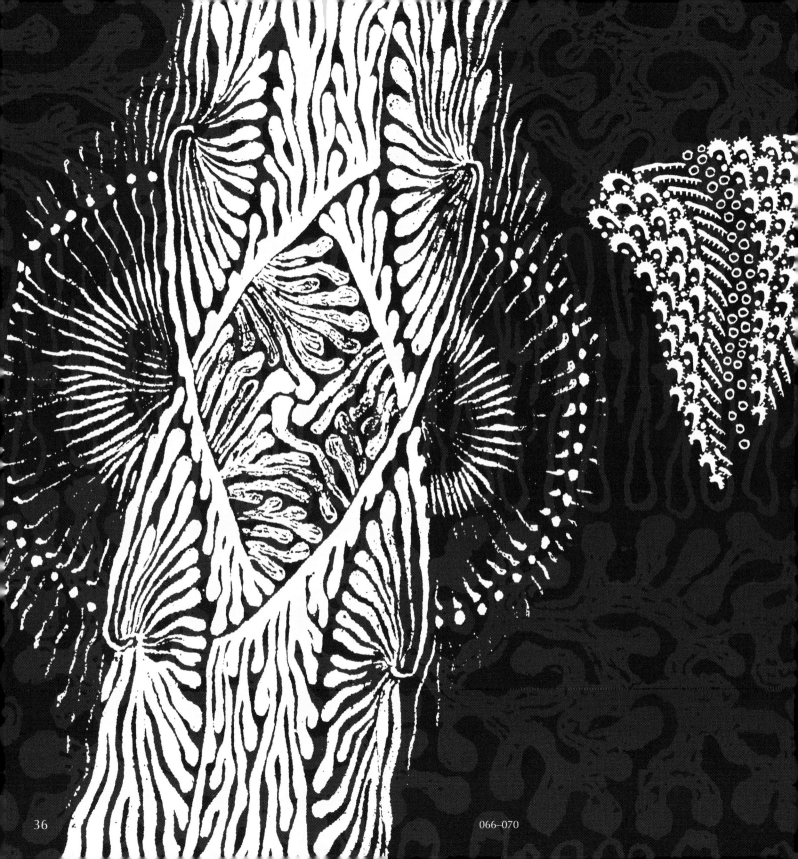

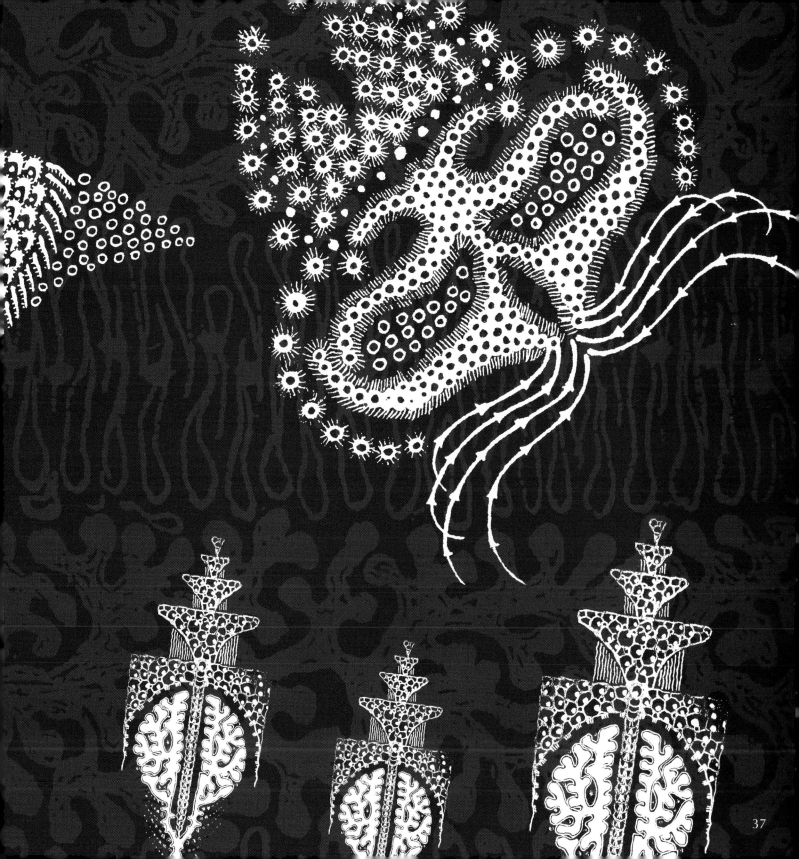

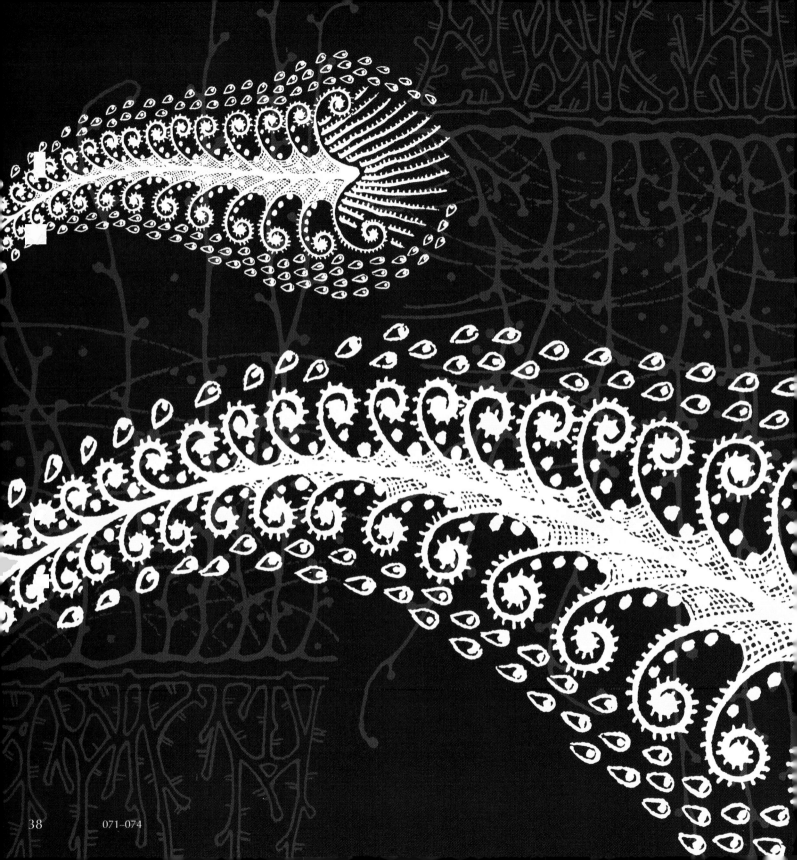

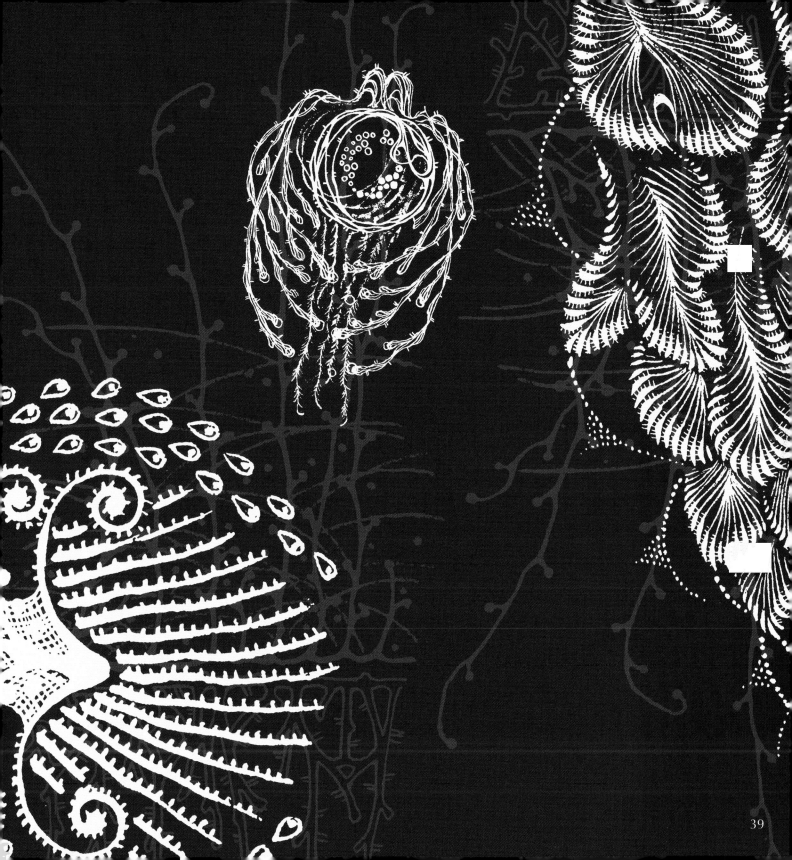

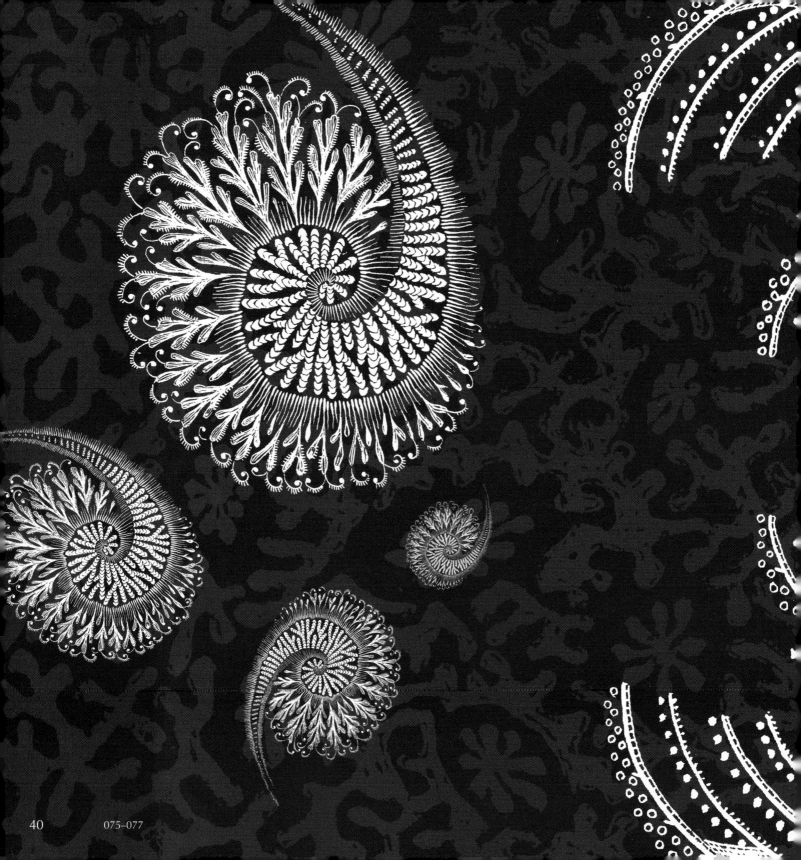

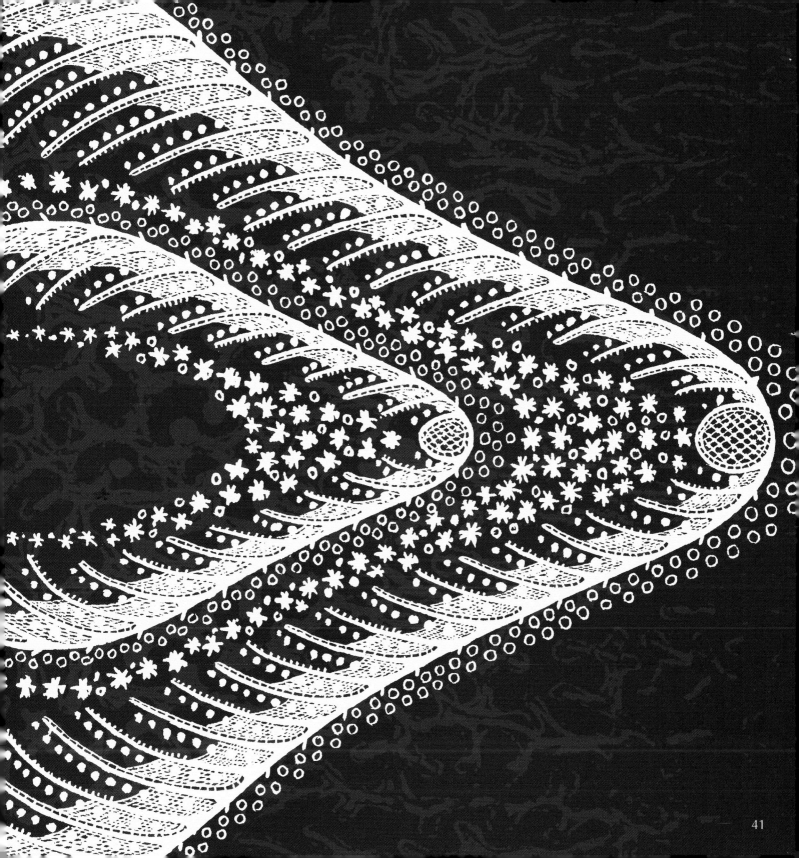

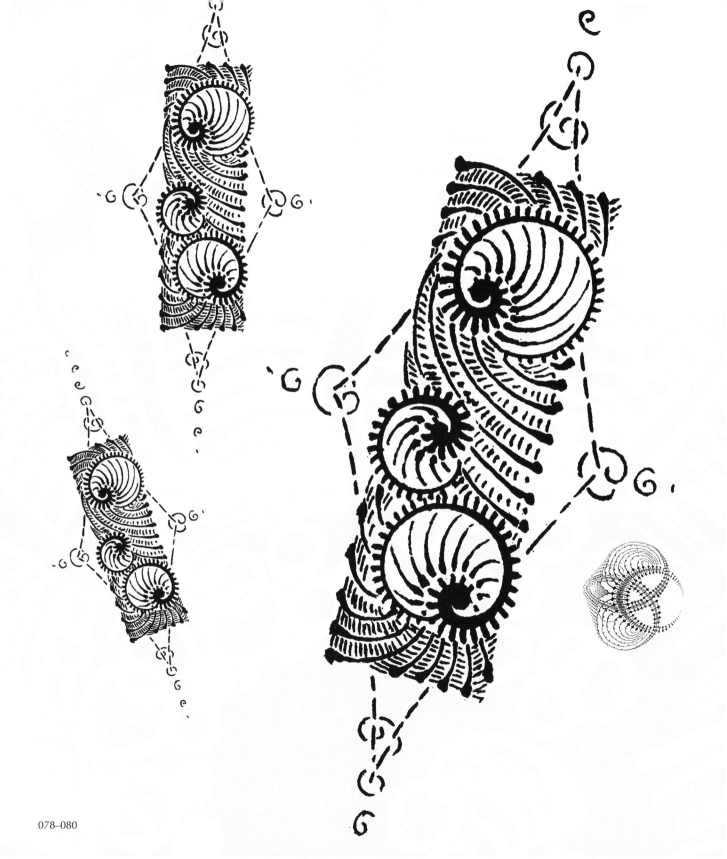

078–080

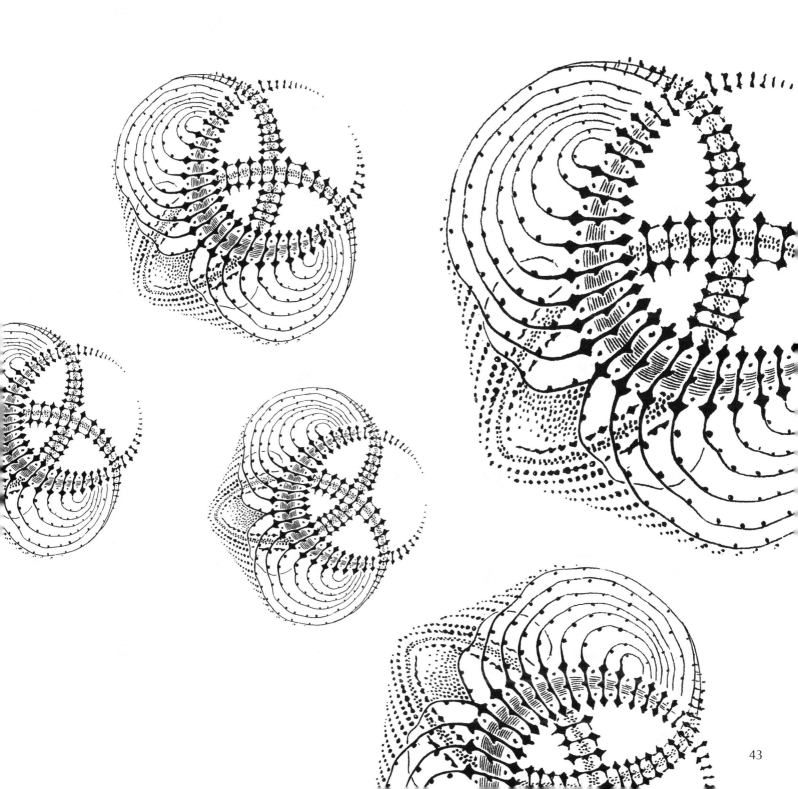

43

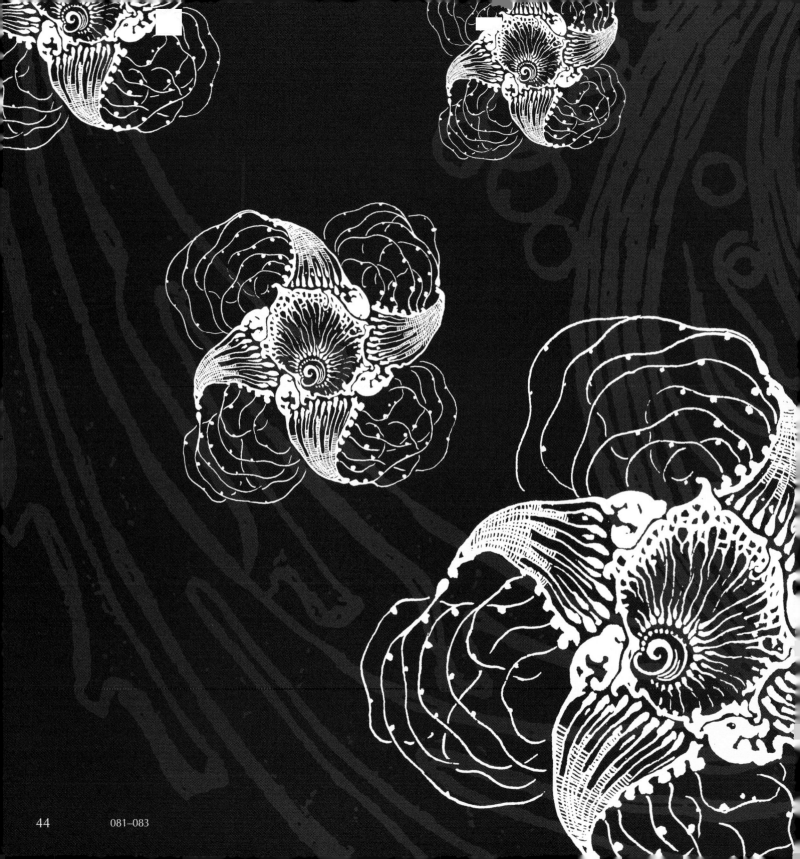

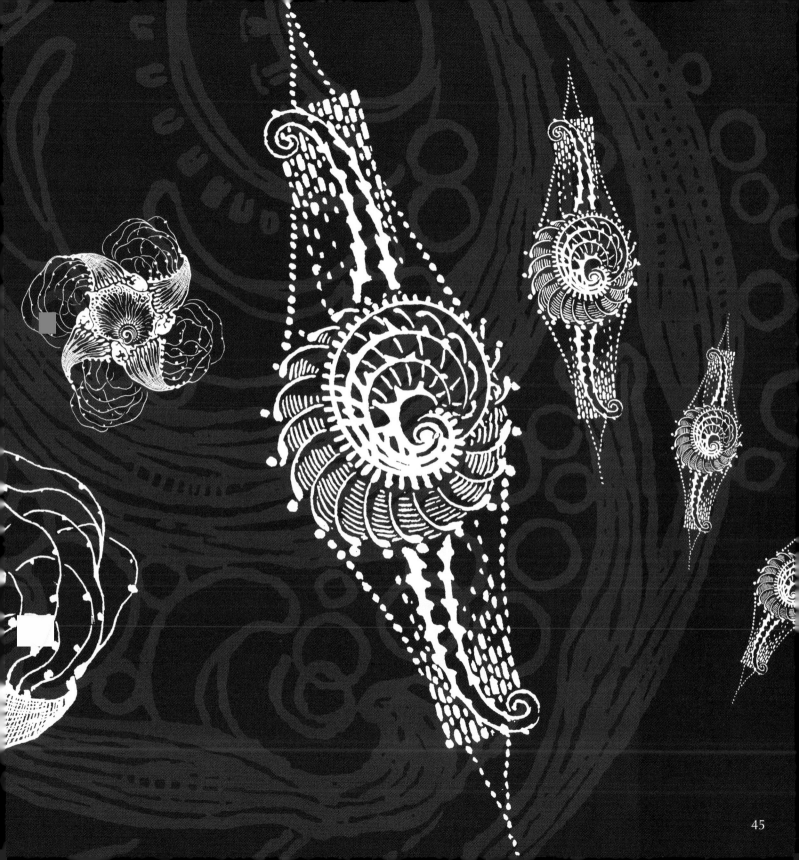

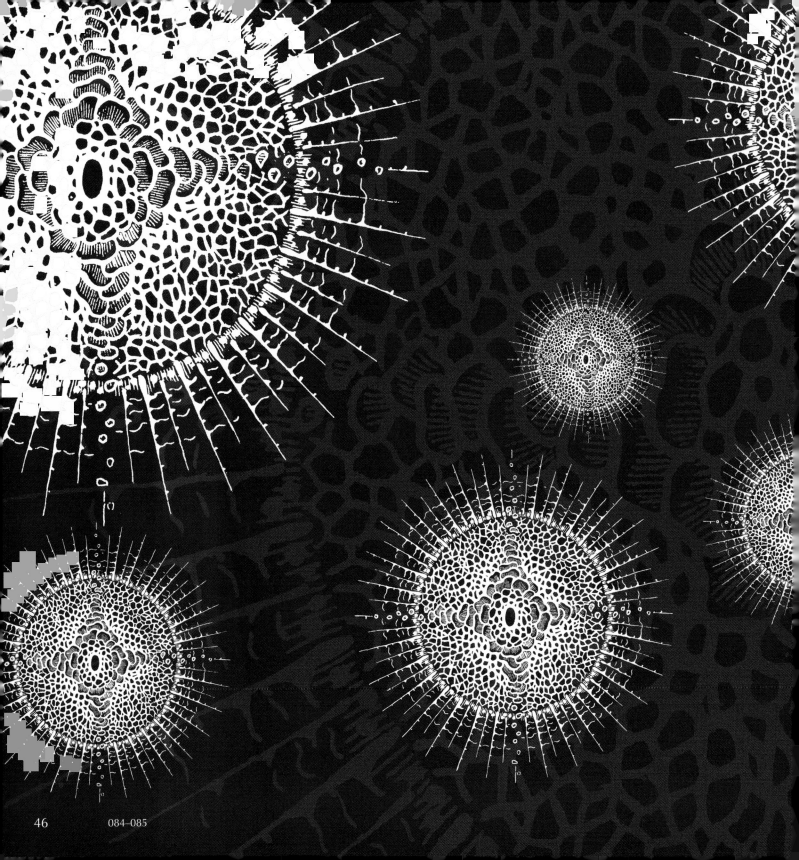

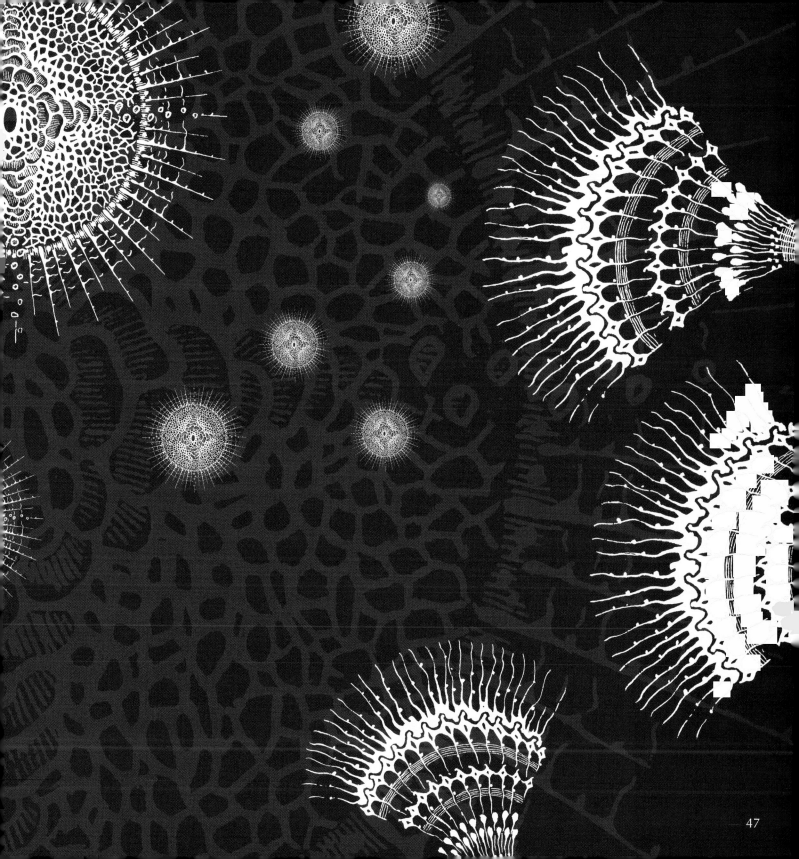

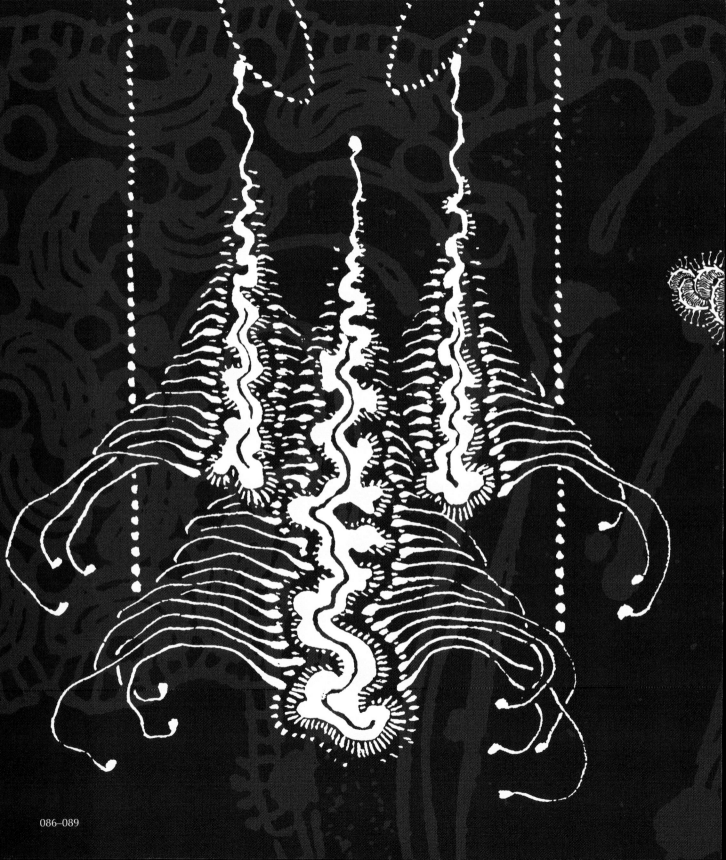

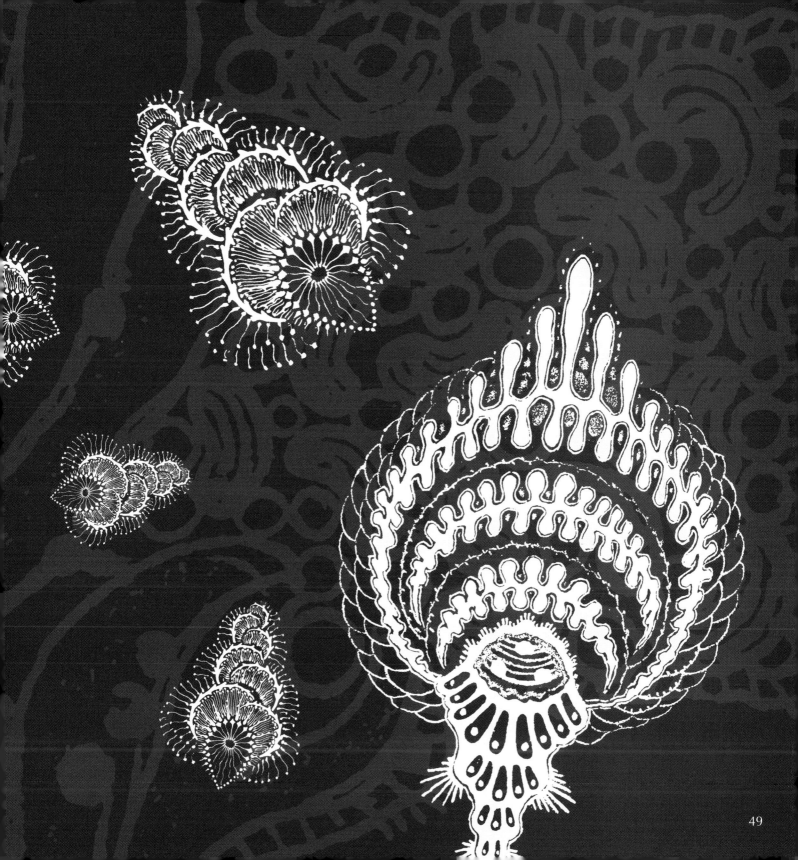

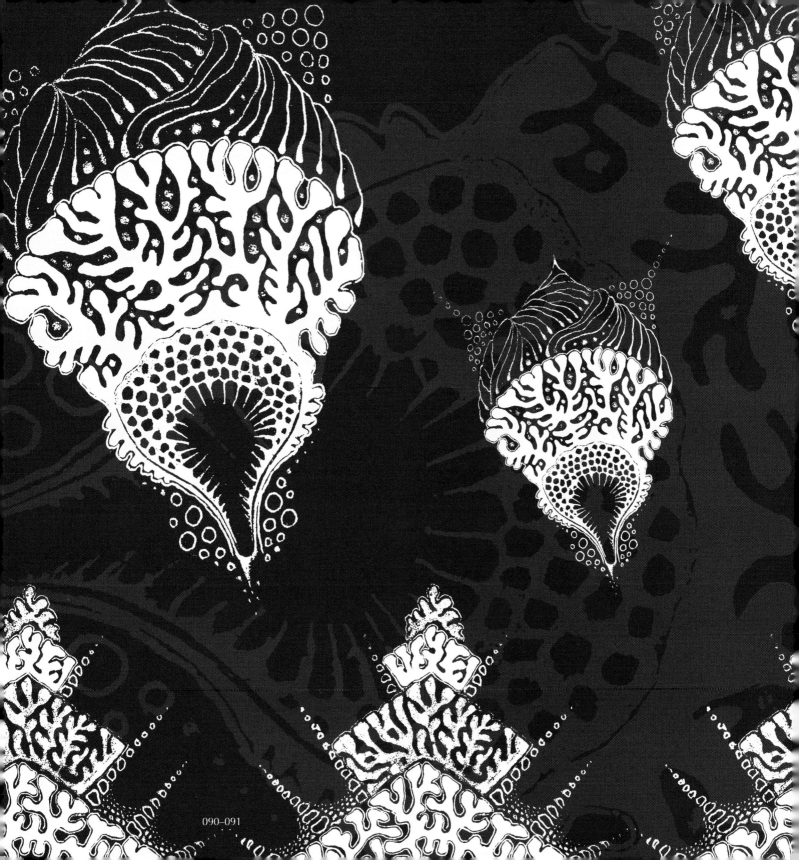

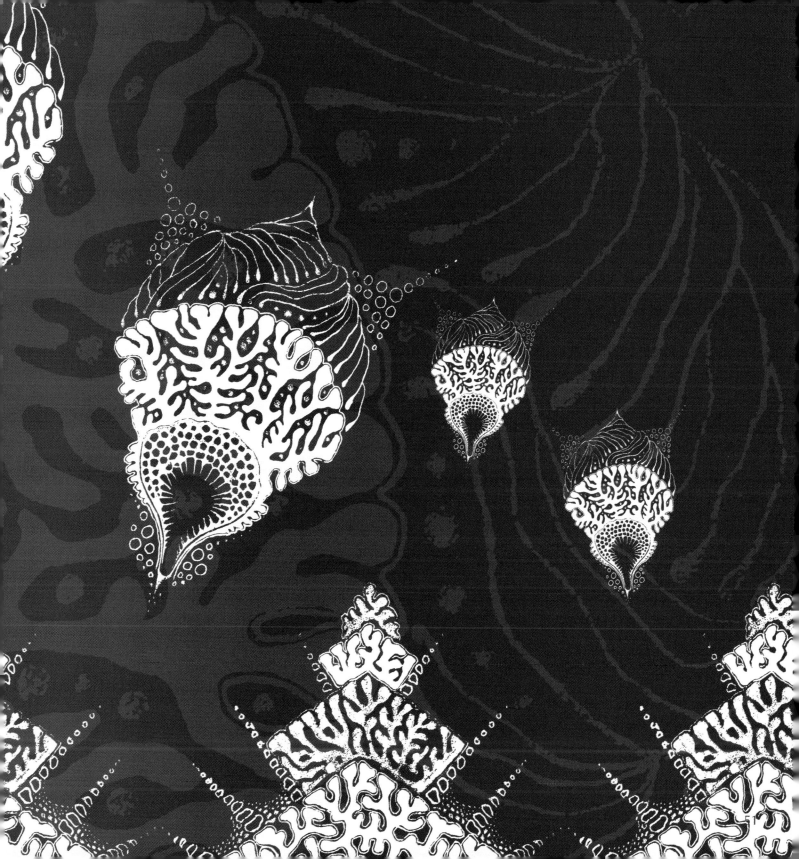

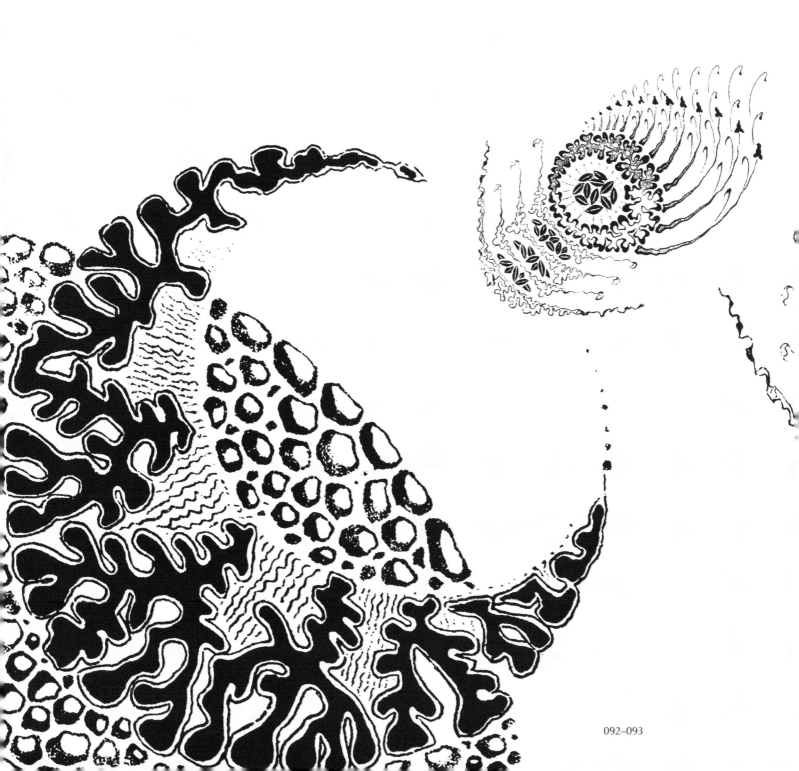

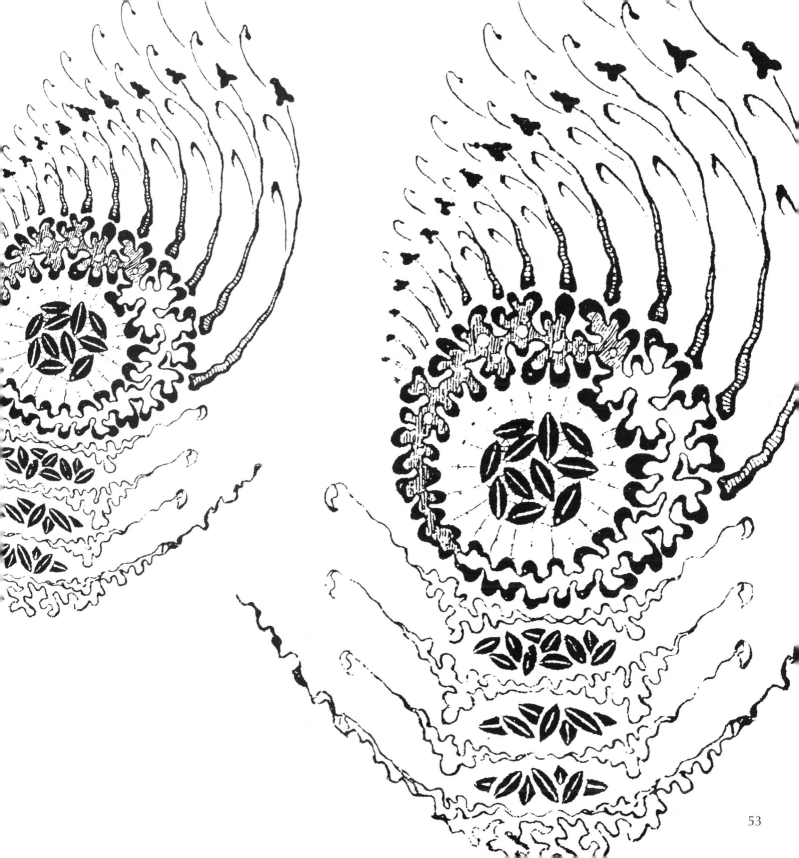

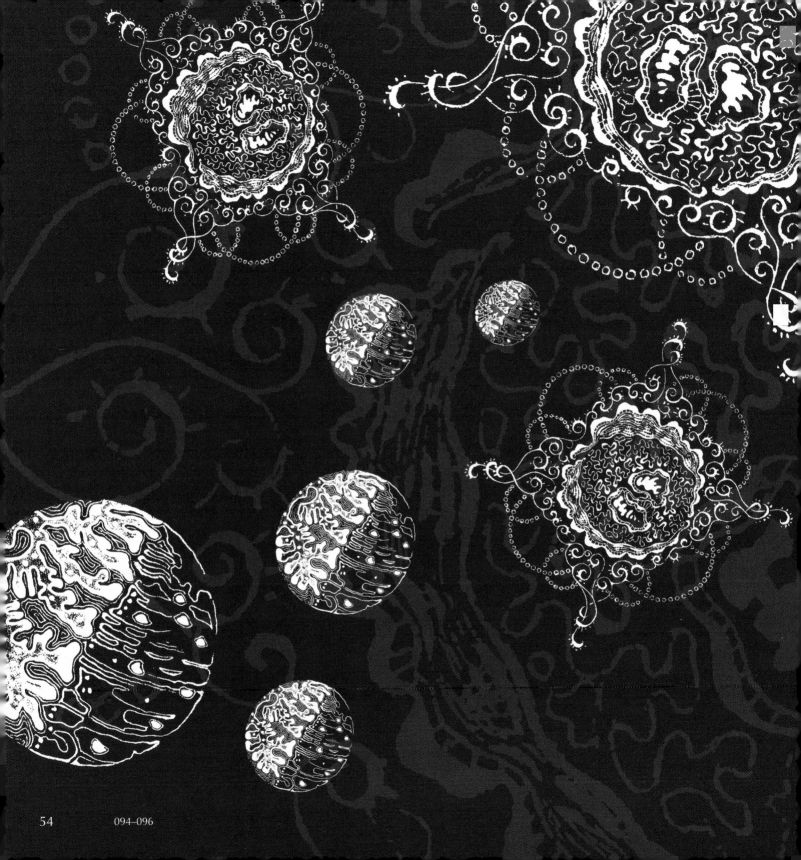

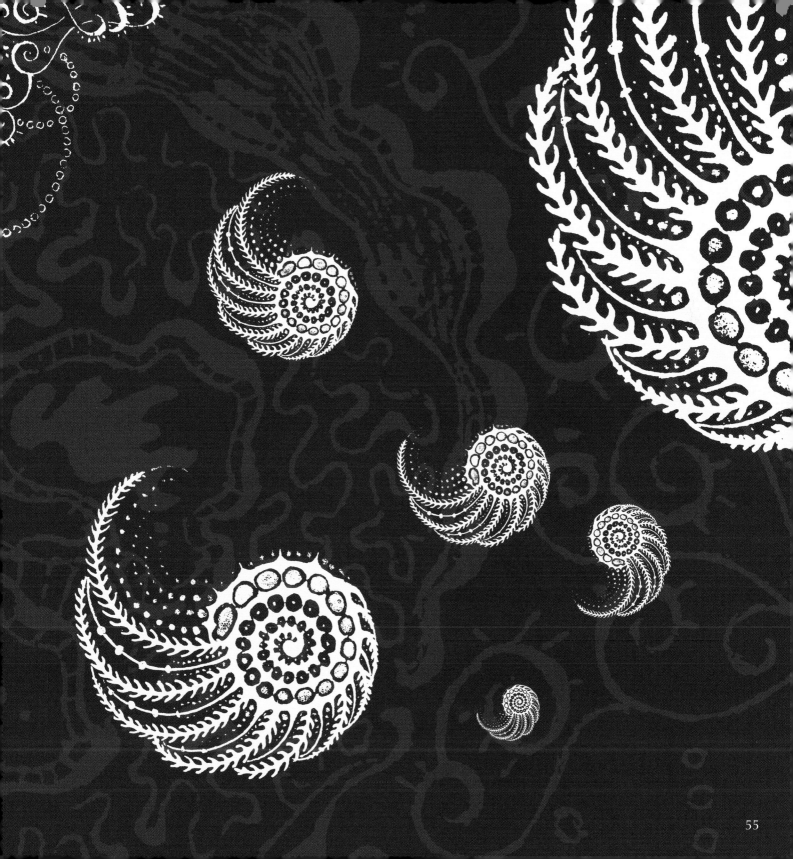

55

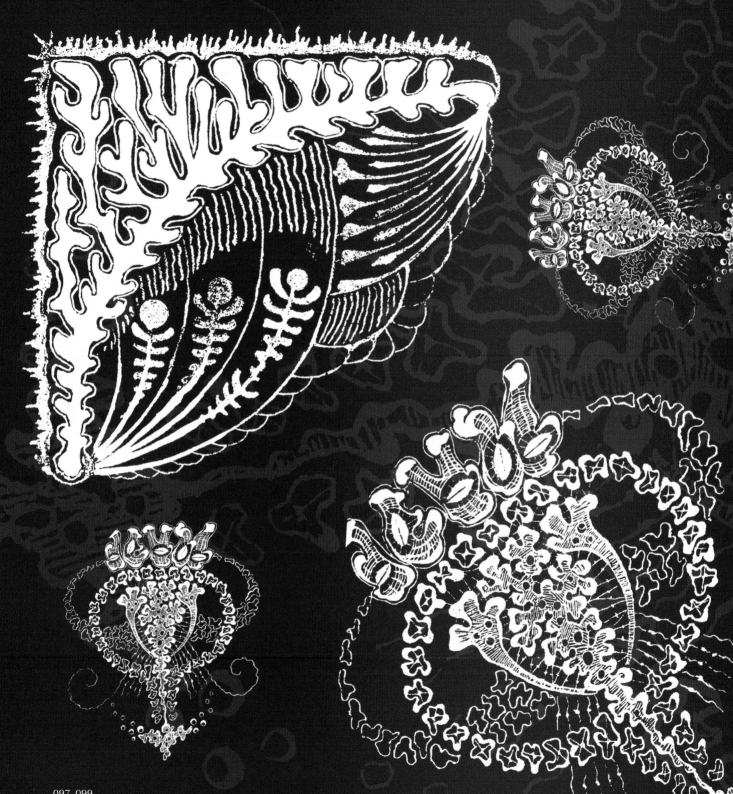

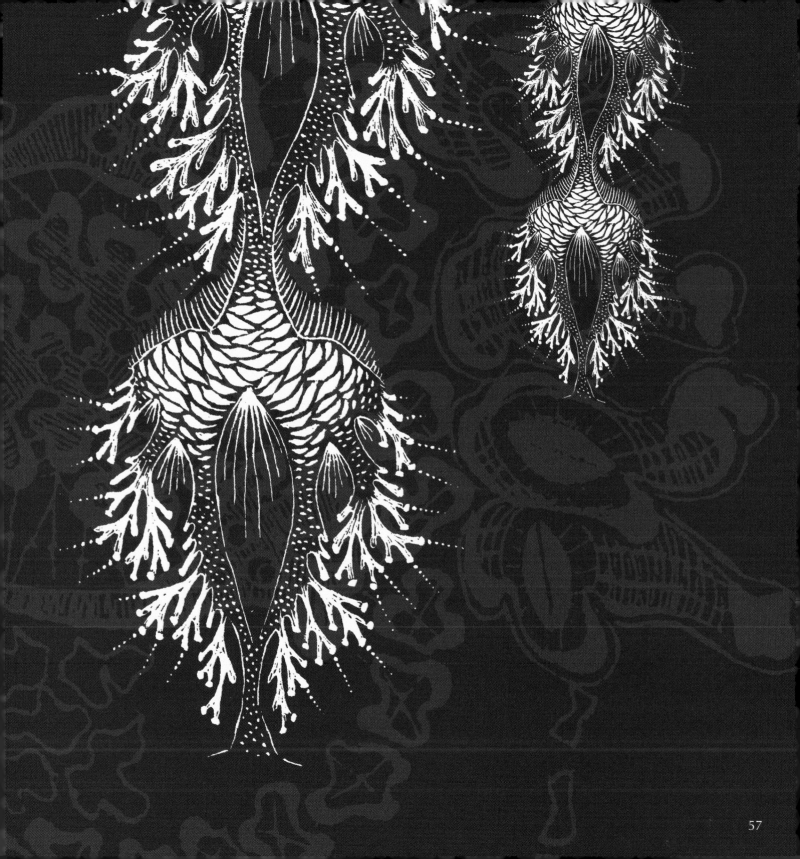

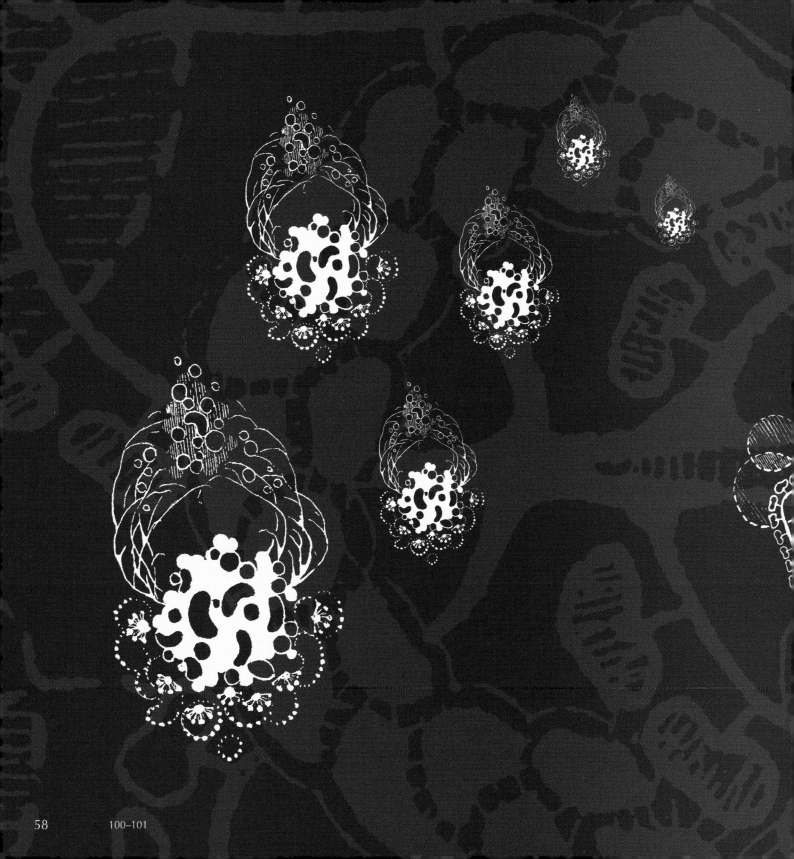

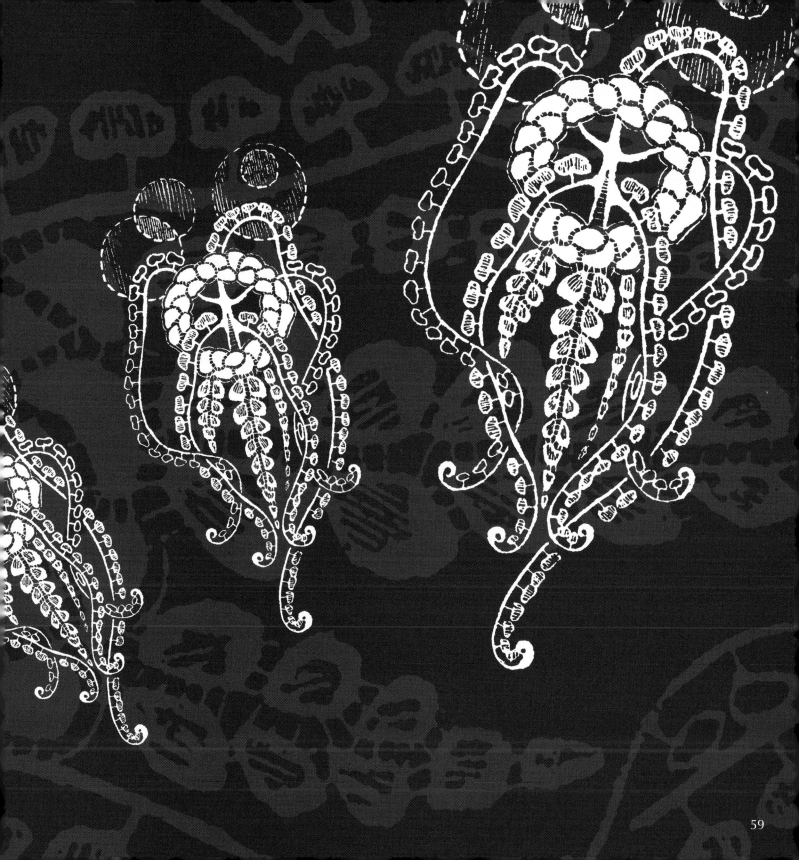

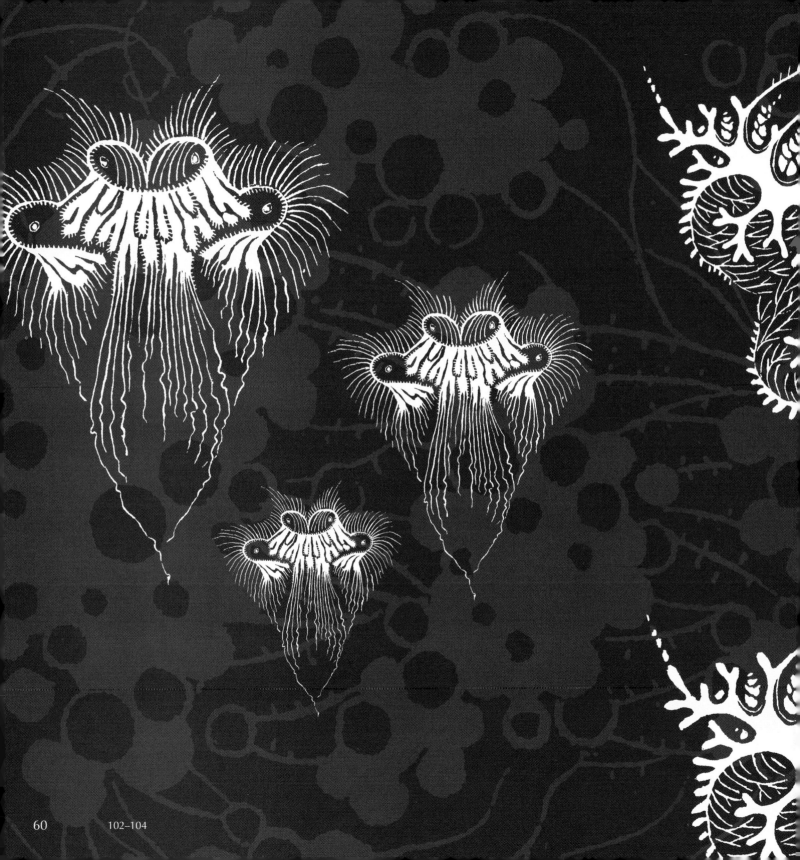

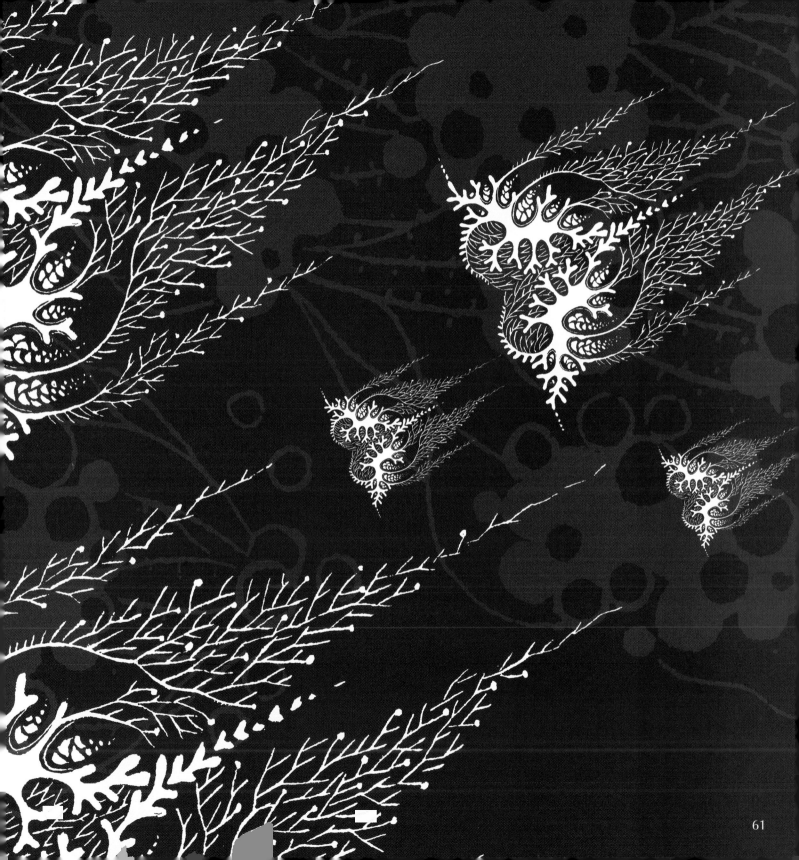

61

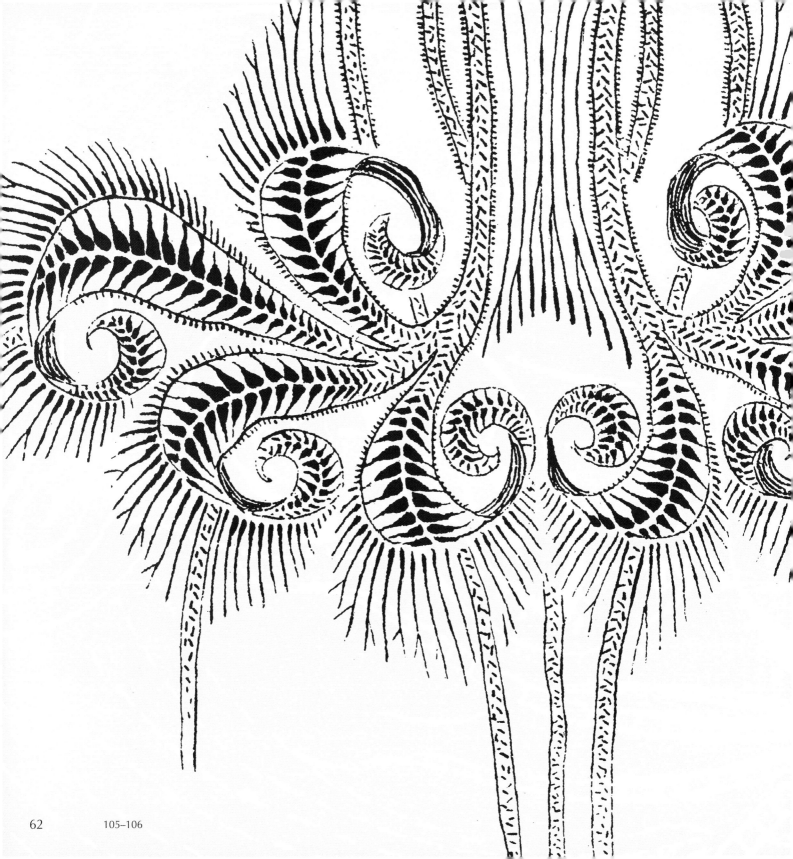

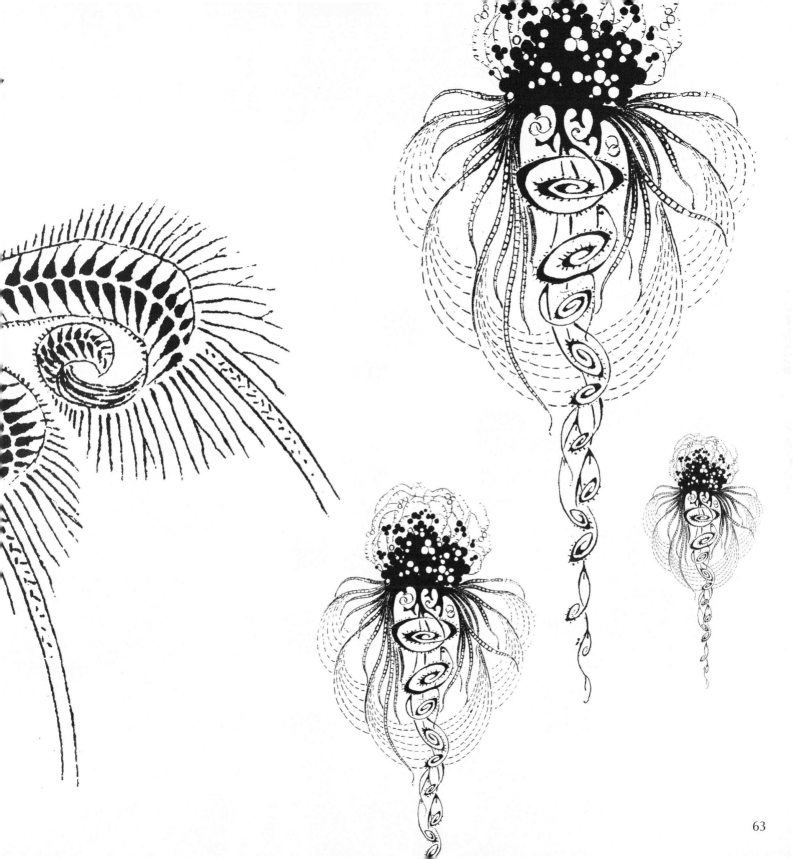

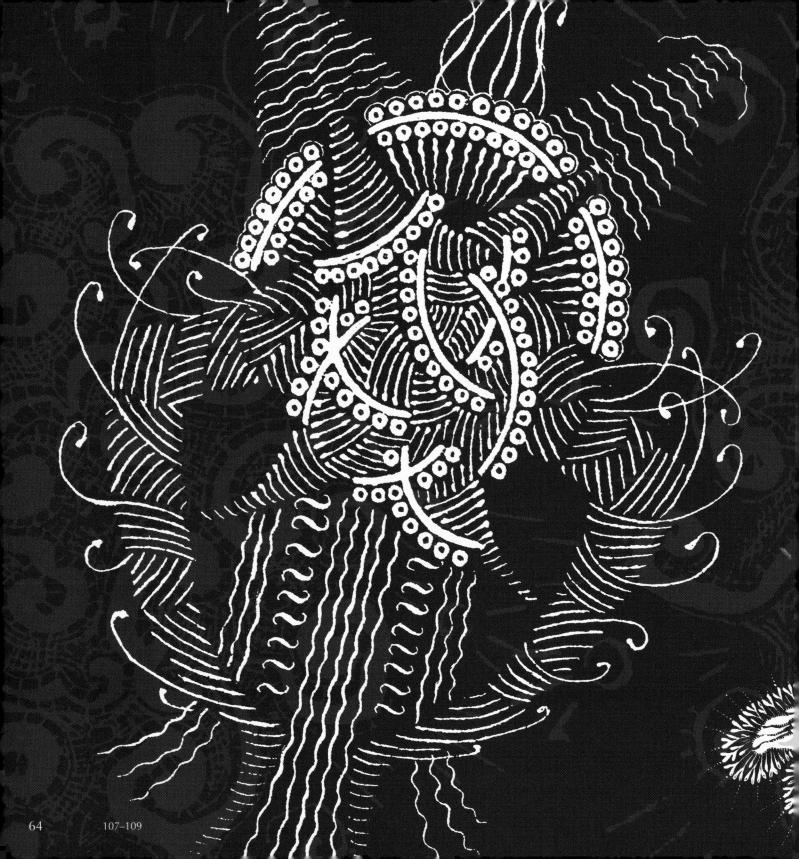

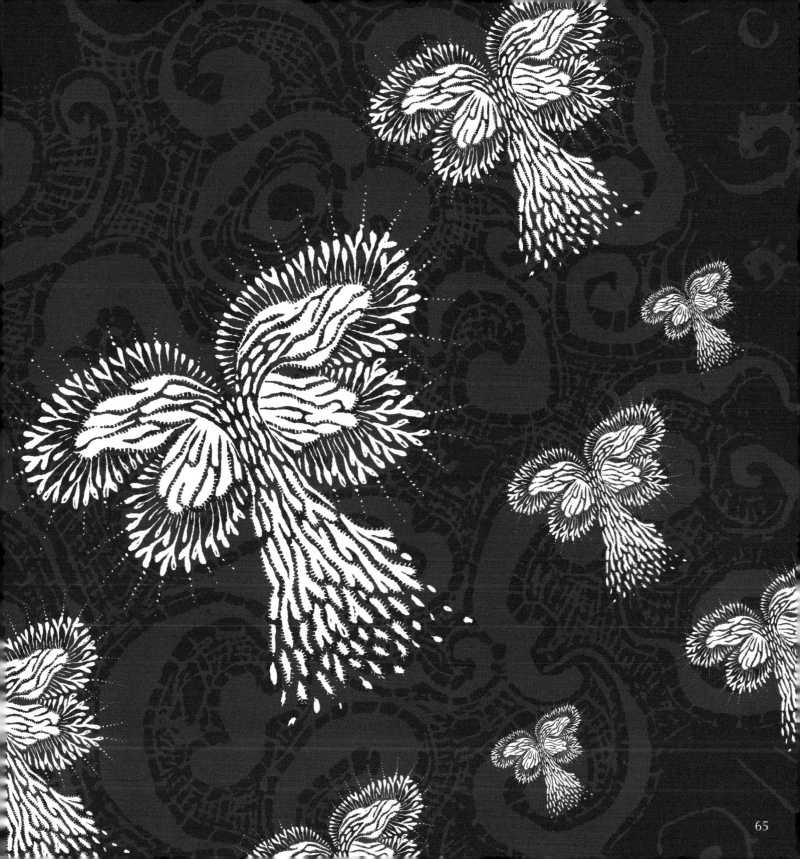

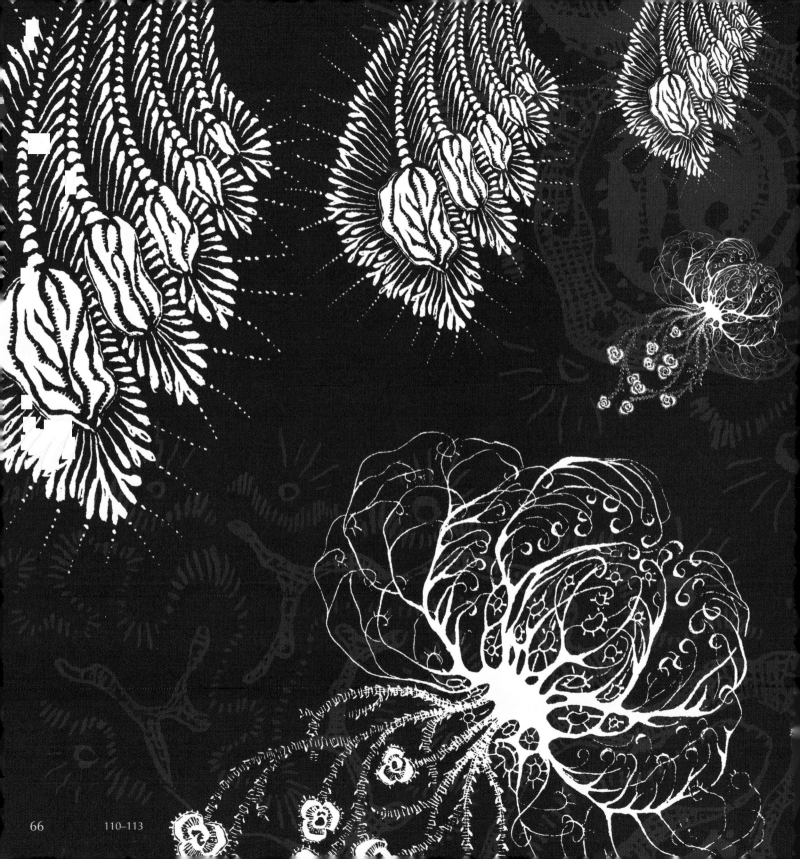

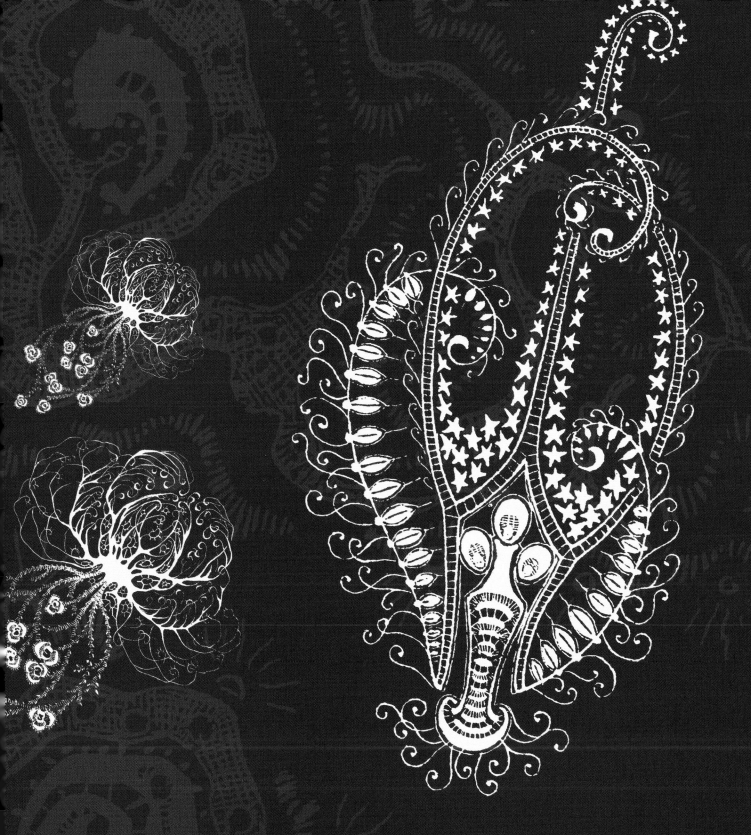

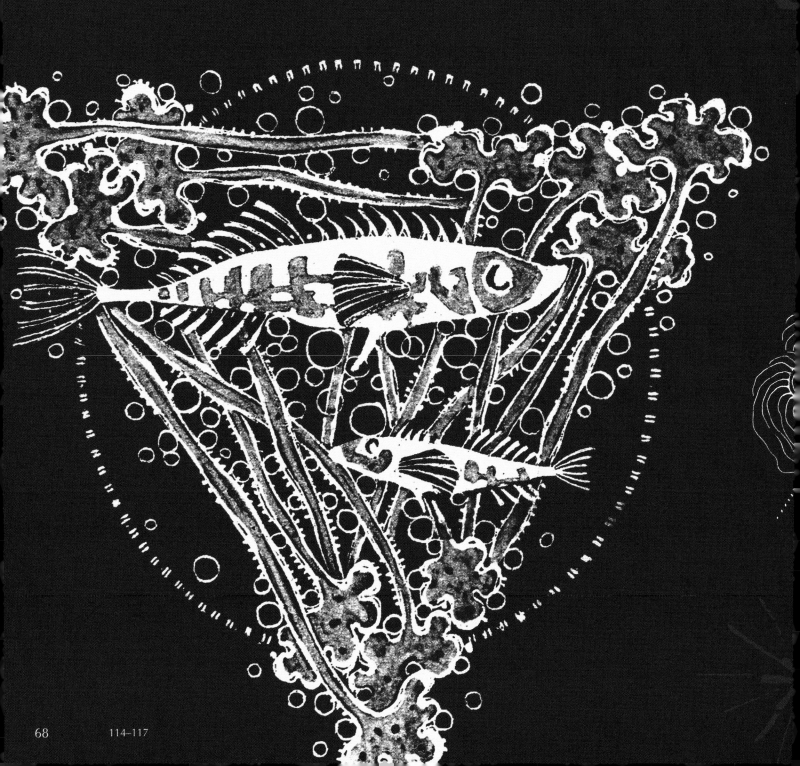

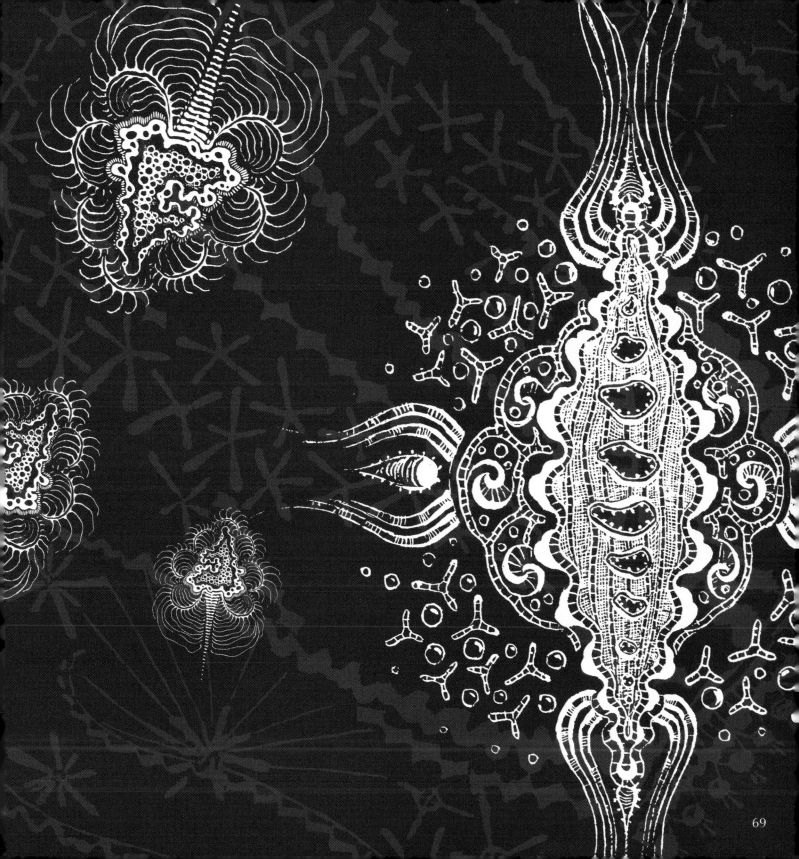

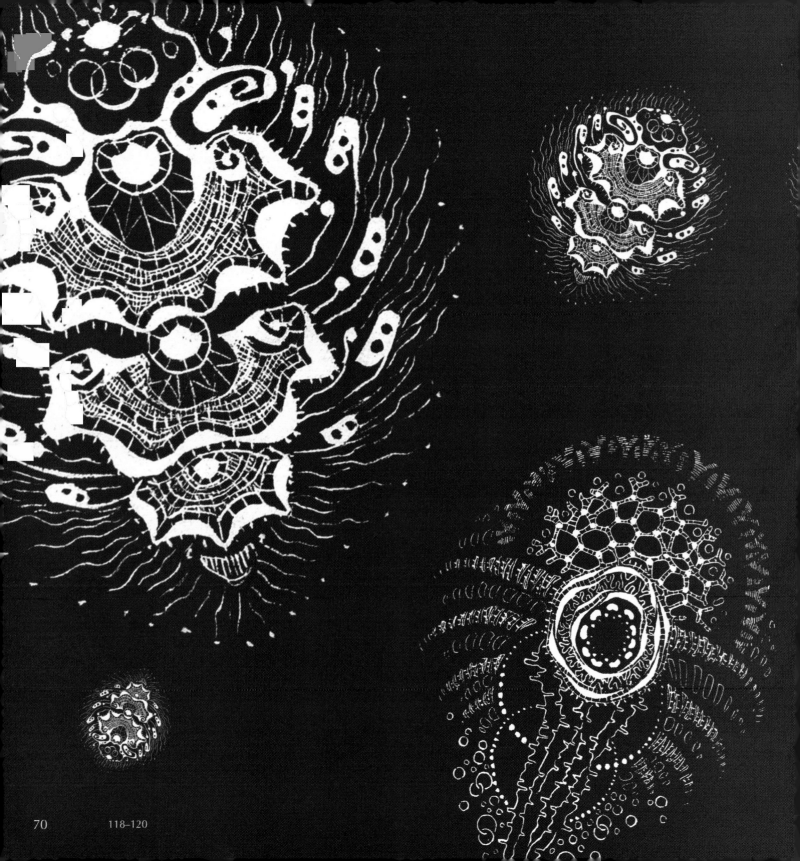

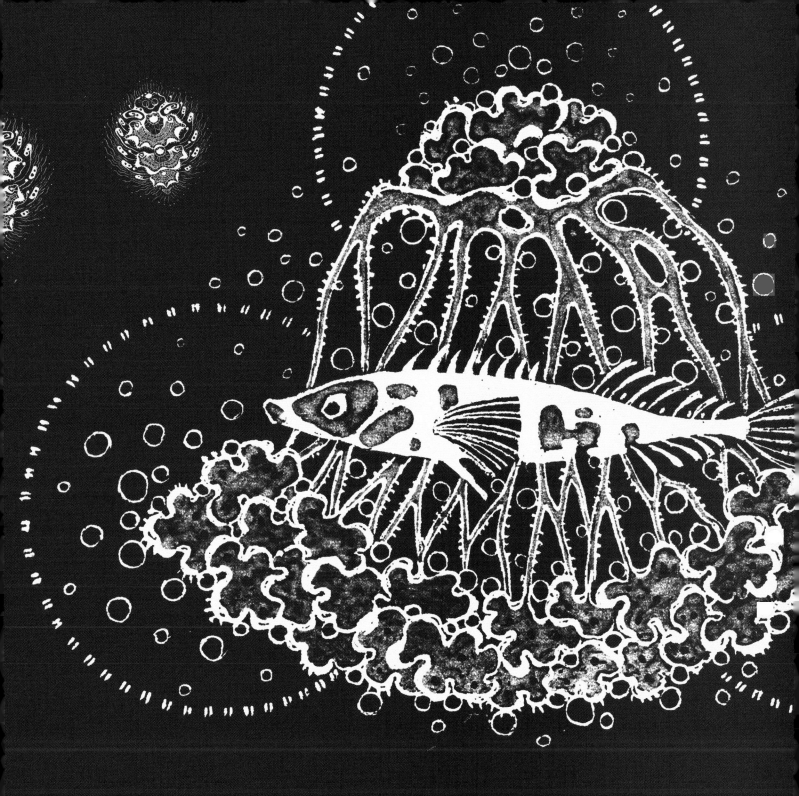

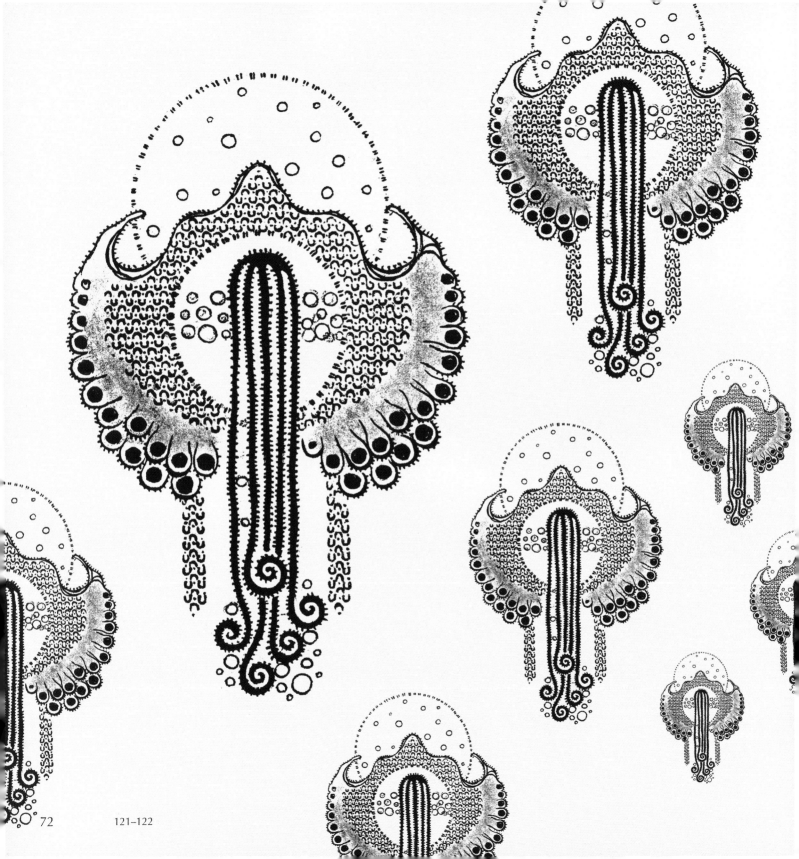

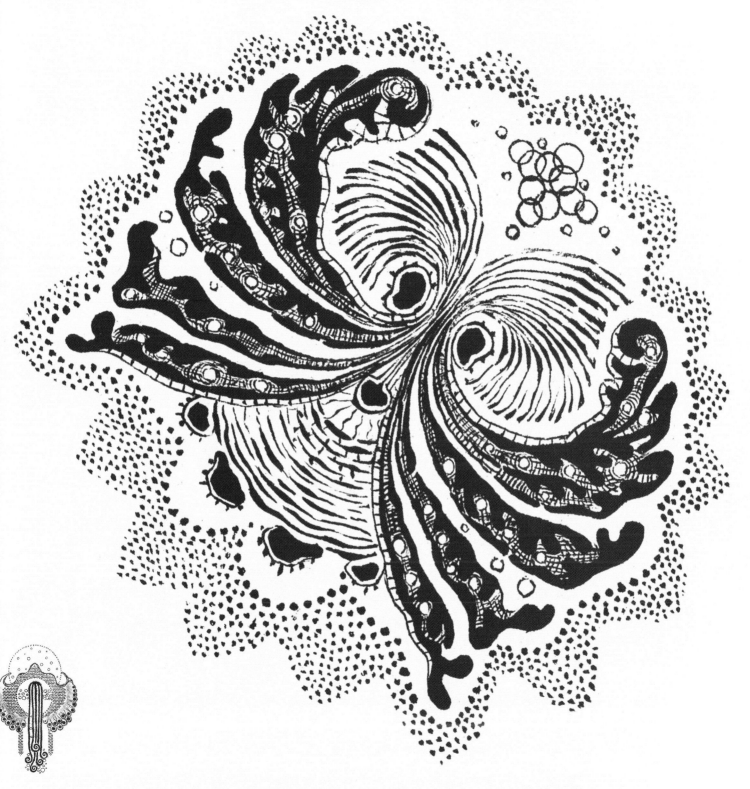

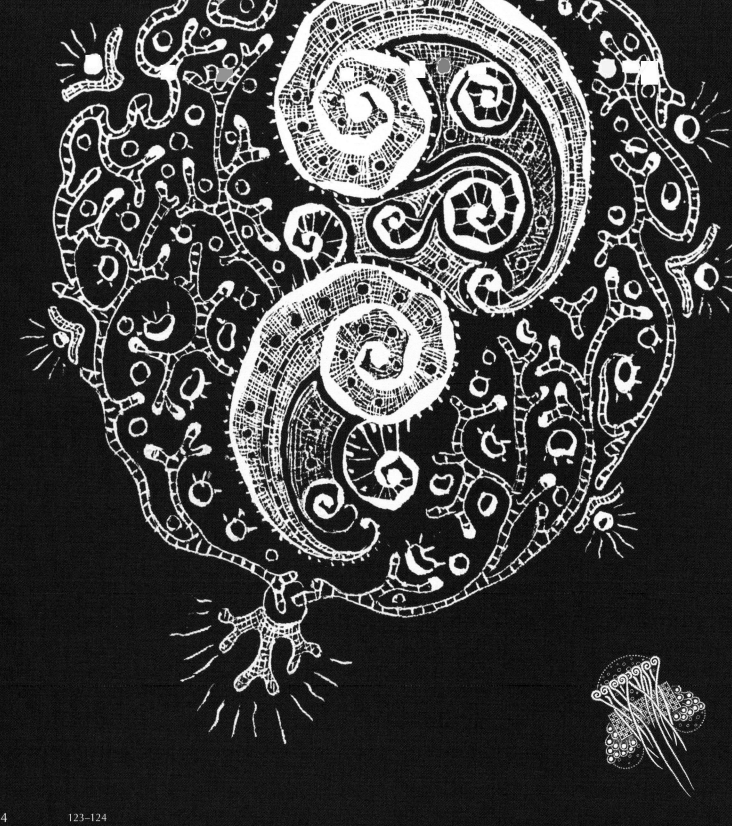

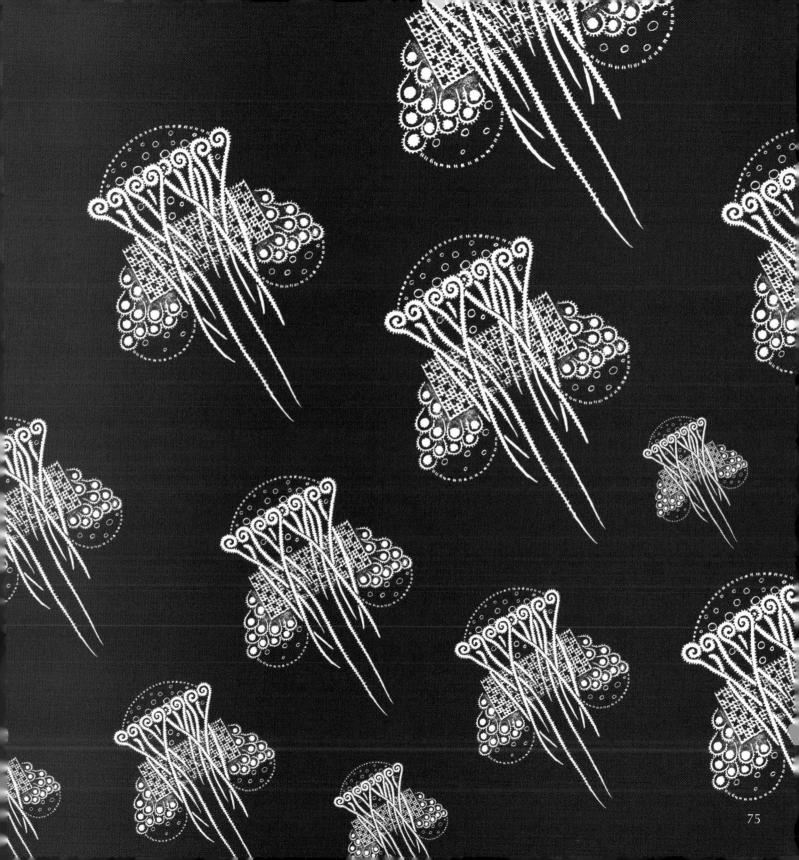

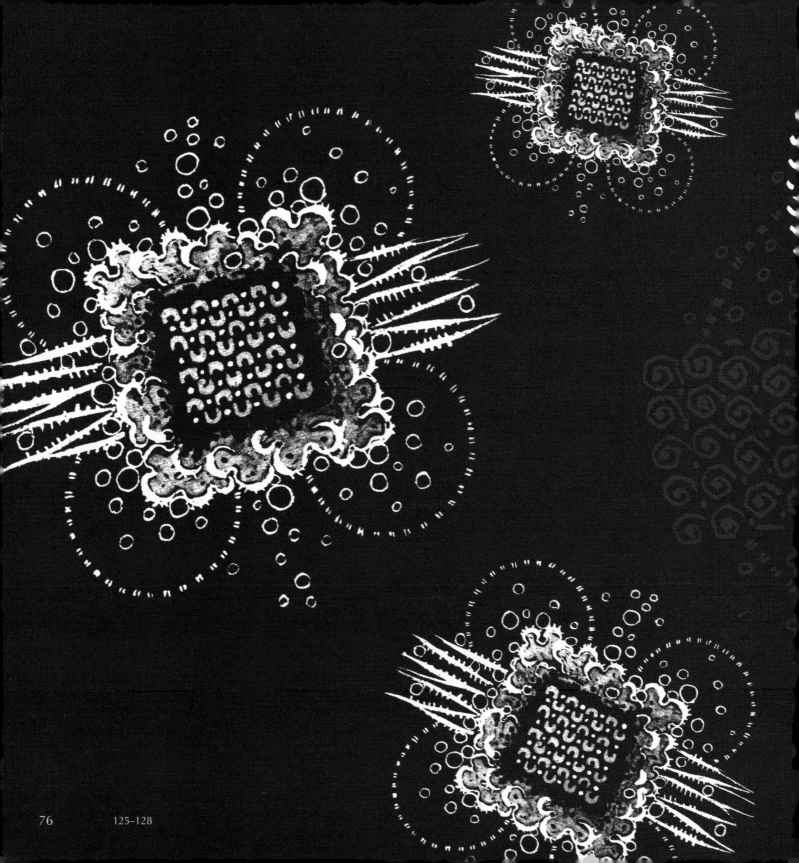

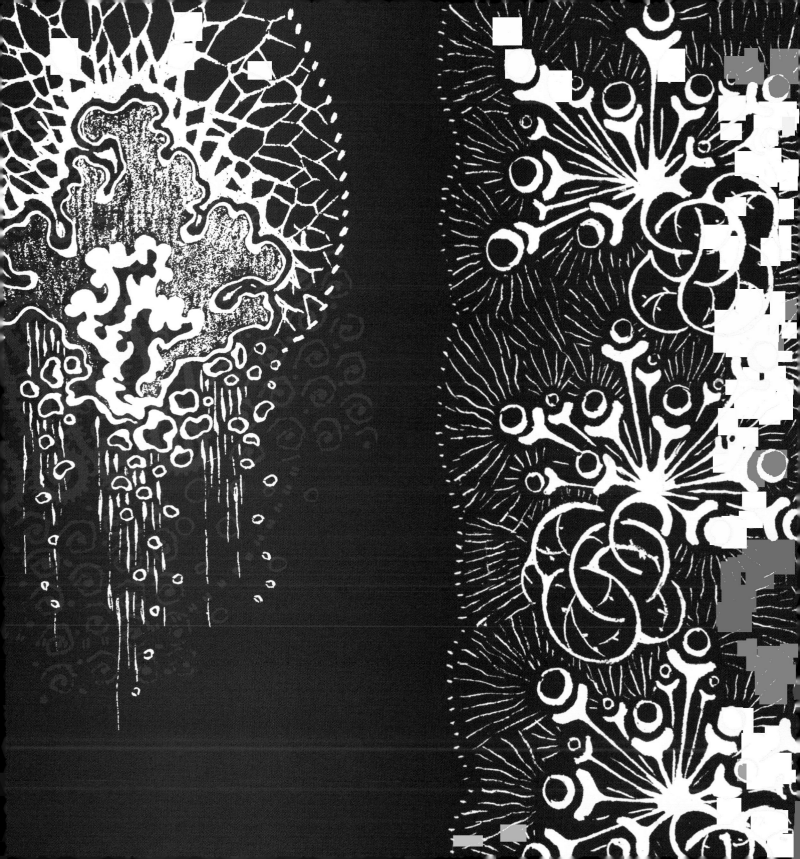

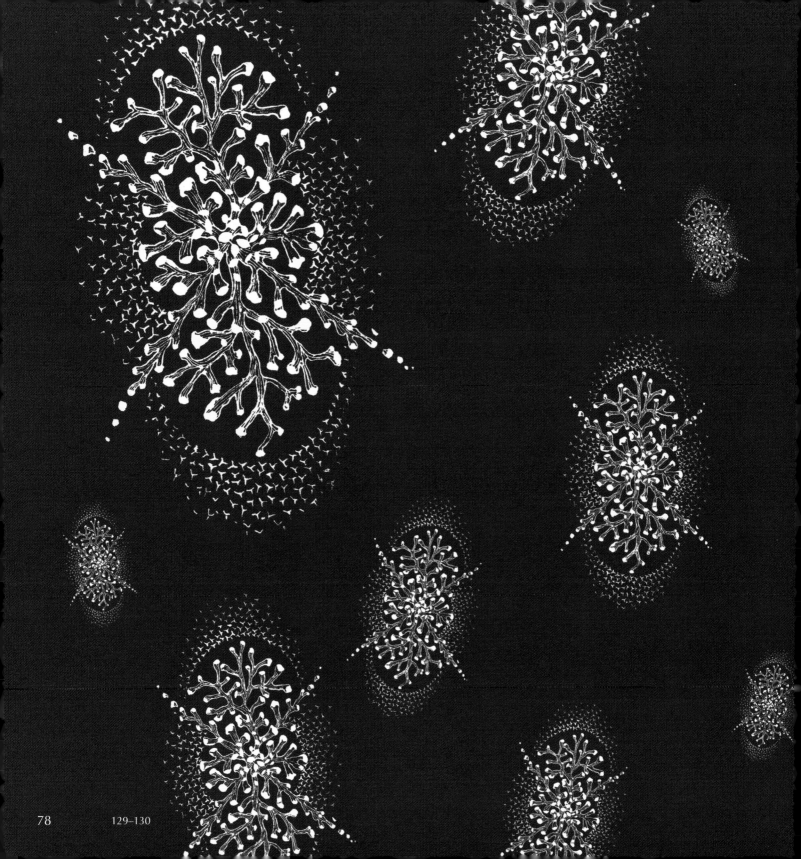

129–130

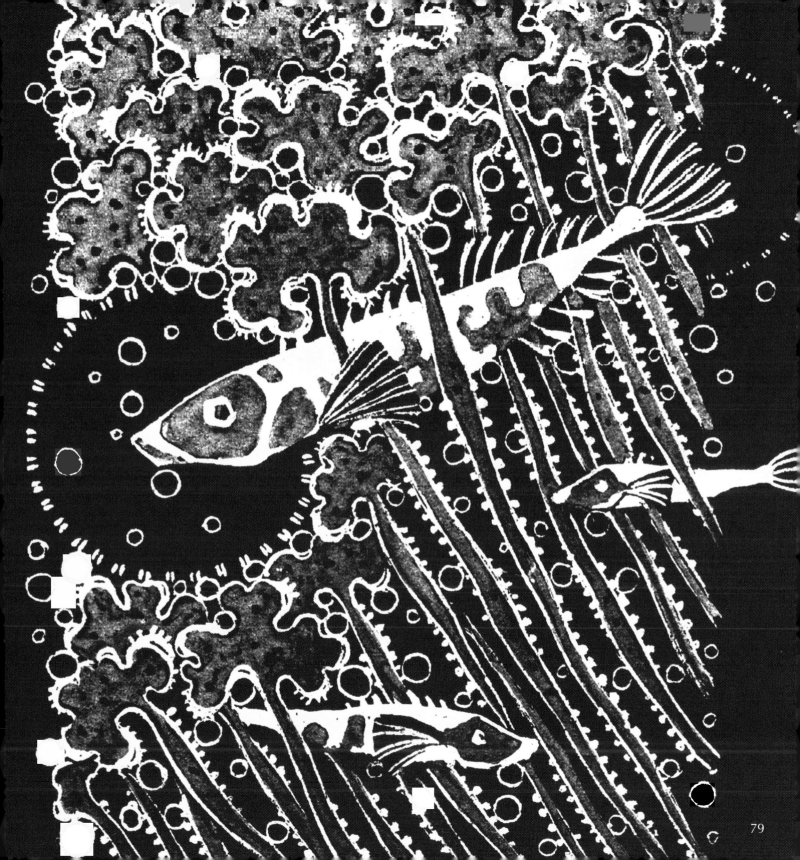

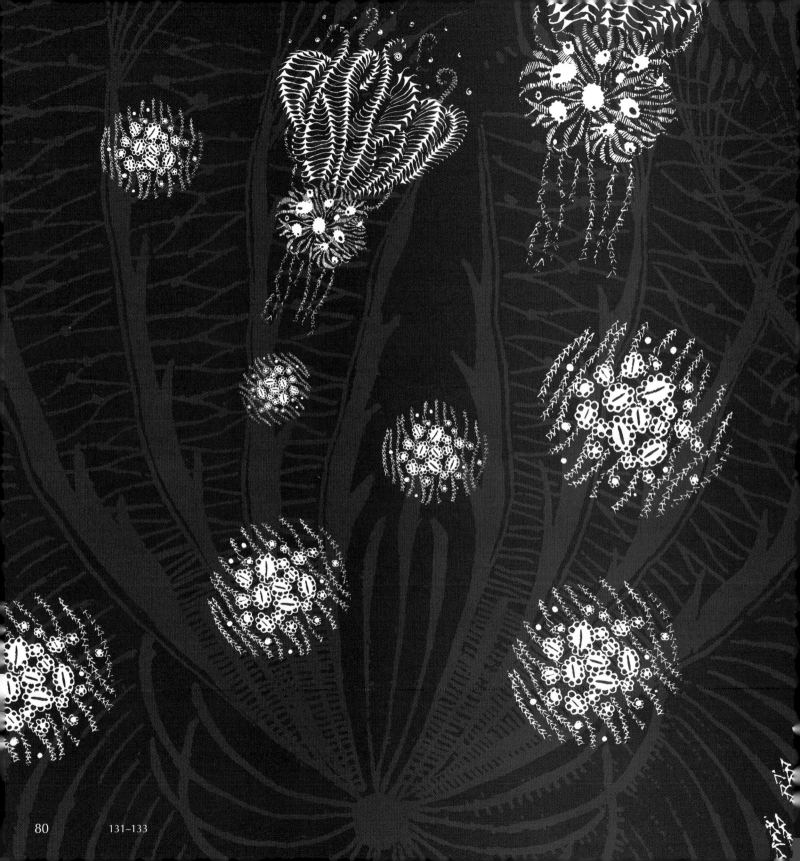

131–133

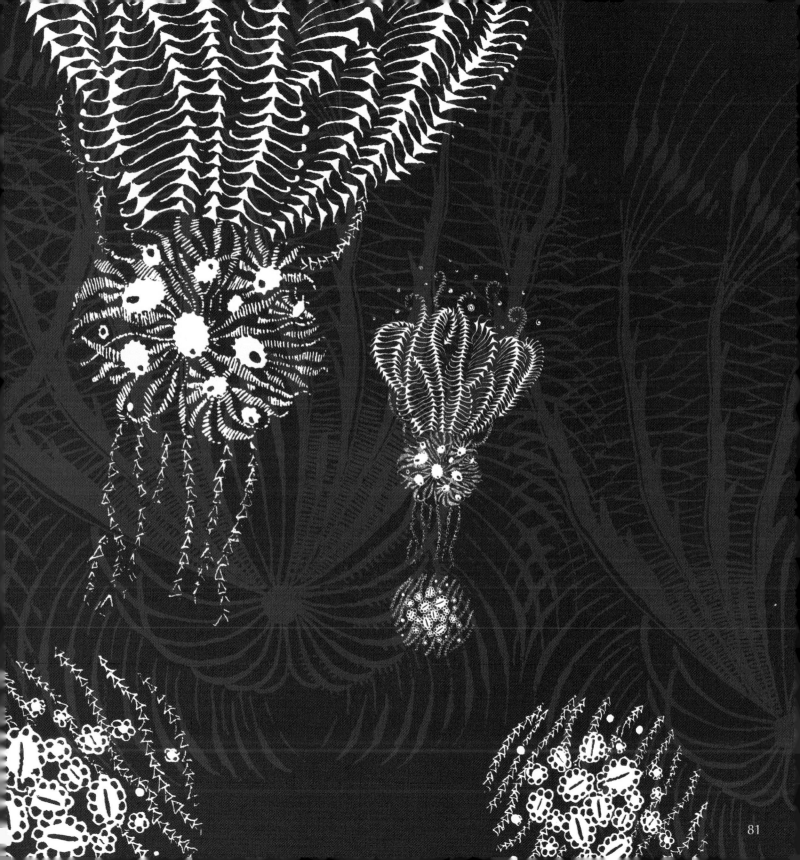

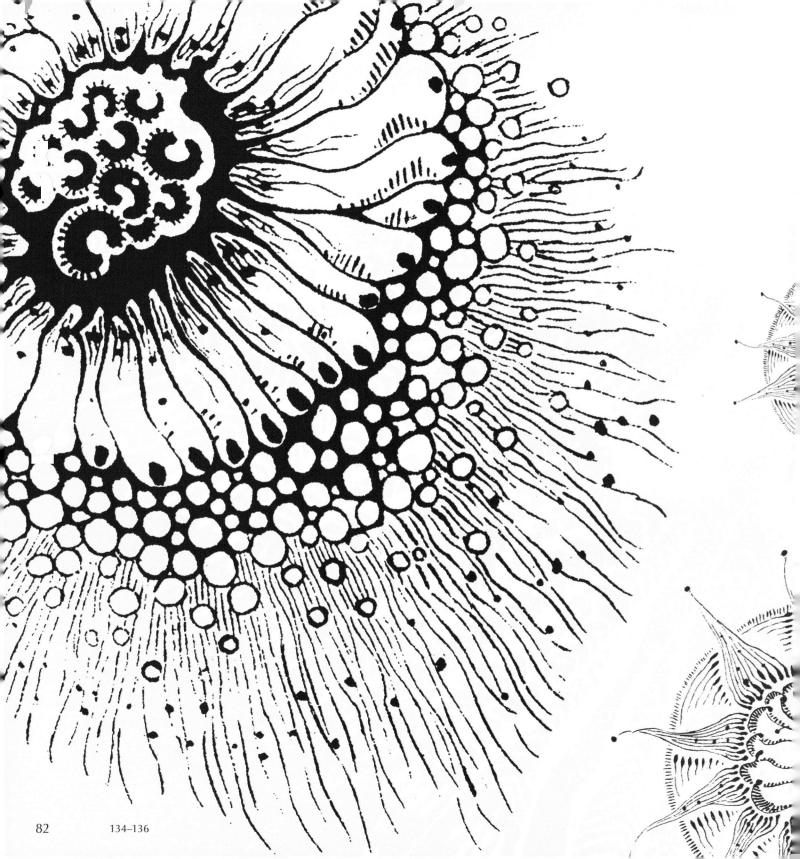

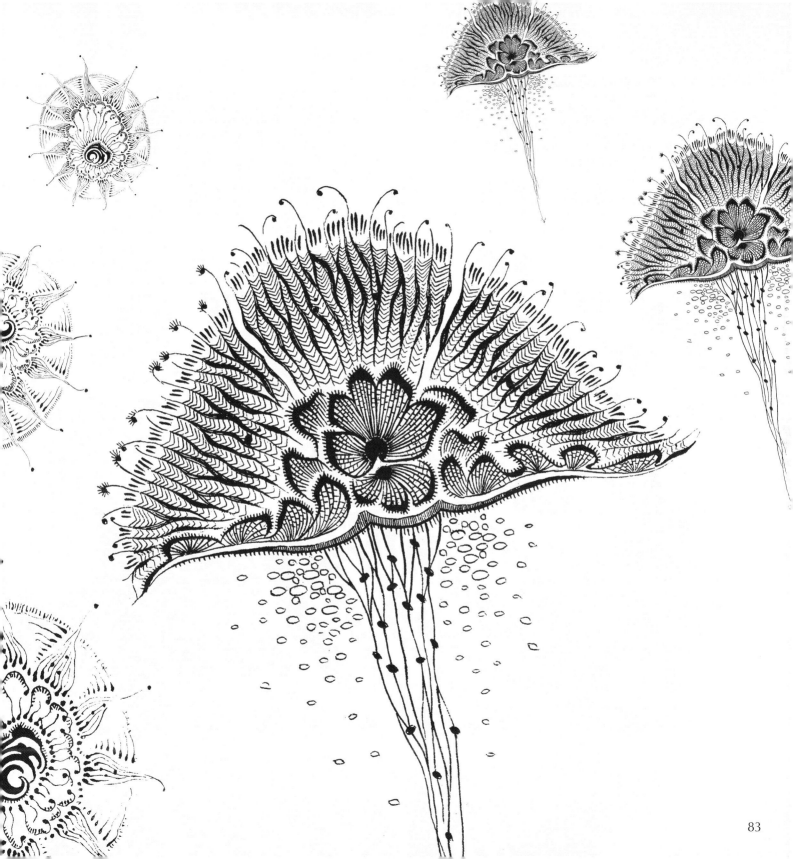

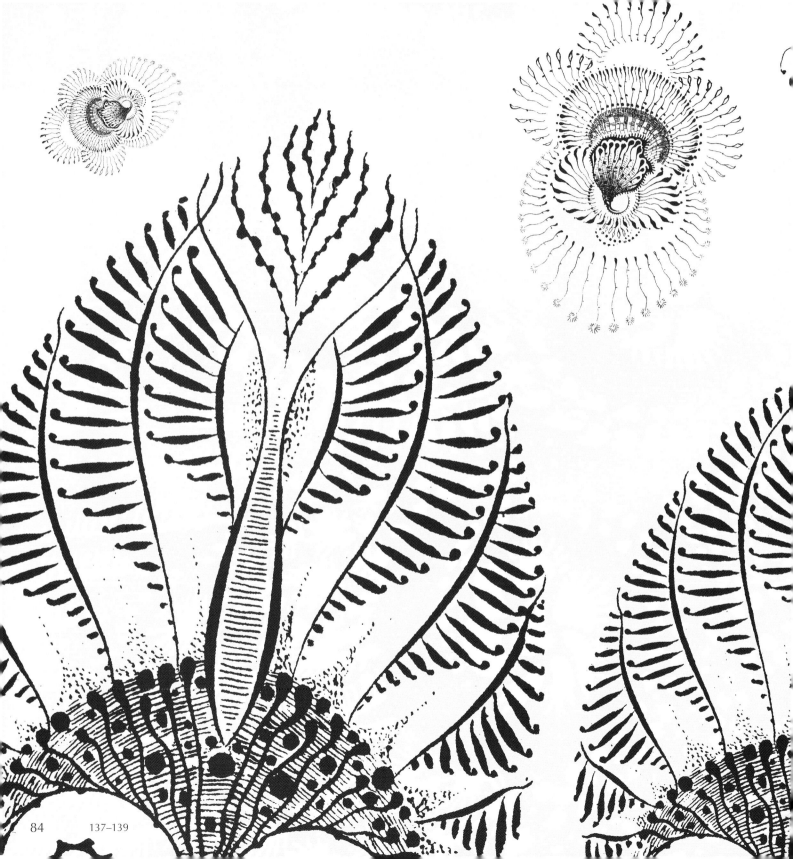

137–139

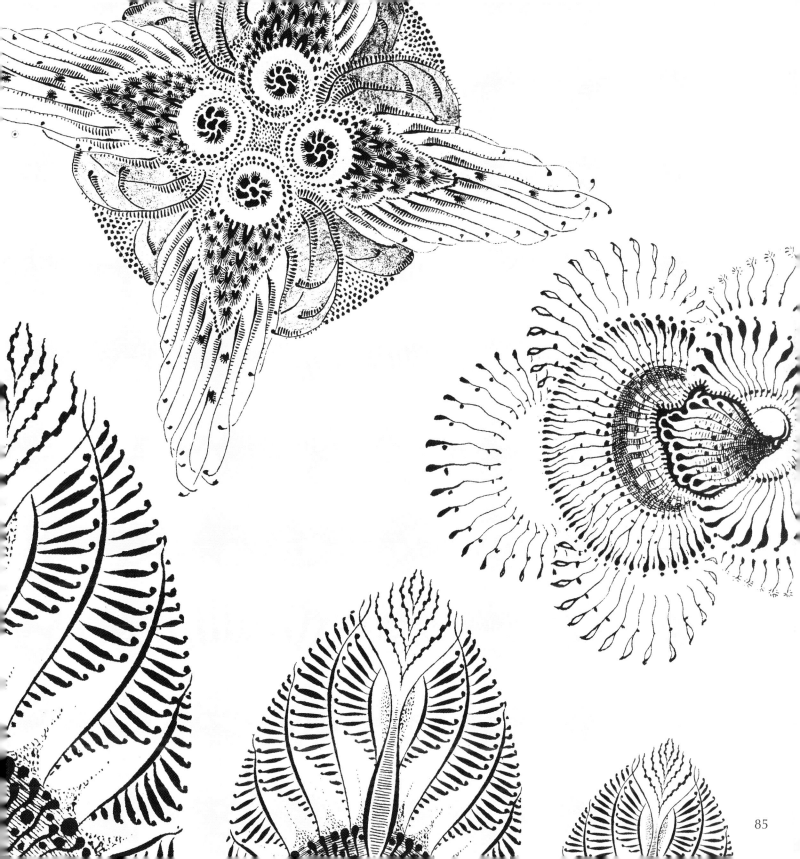

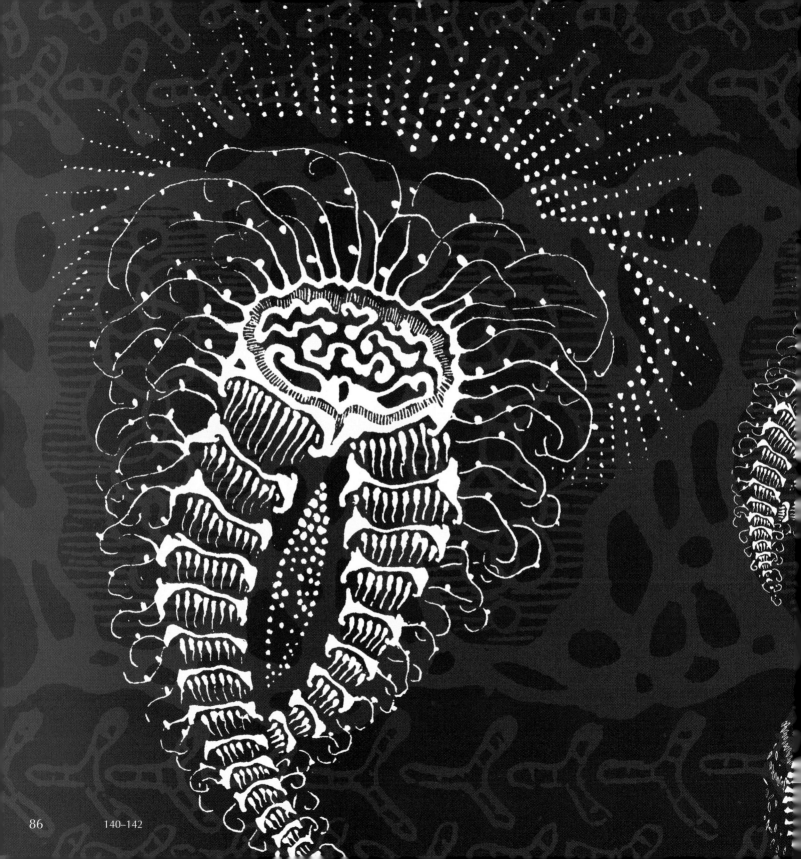

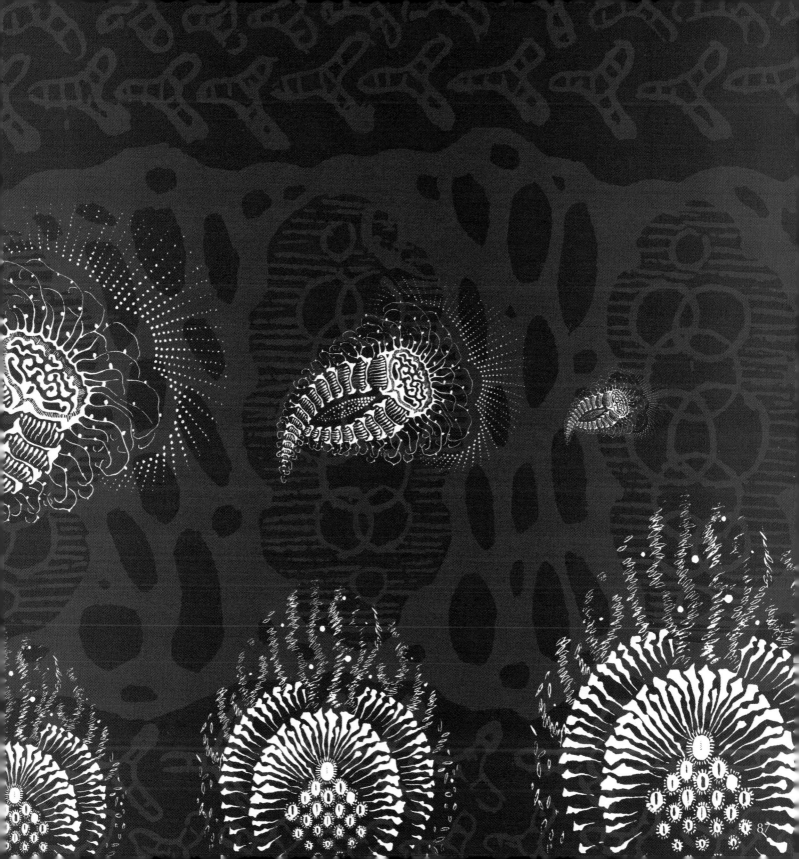

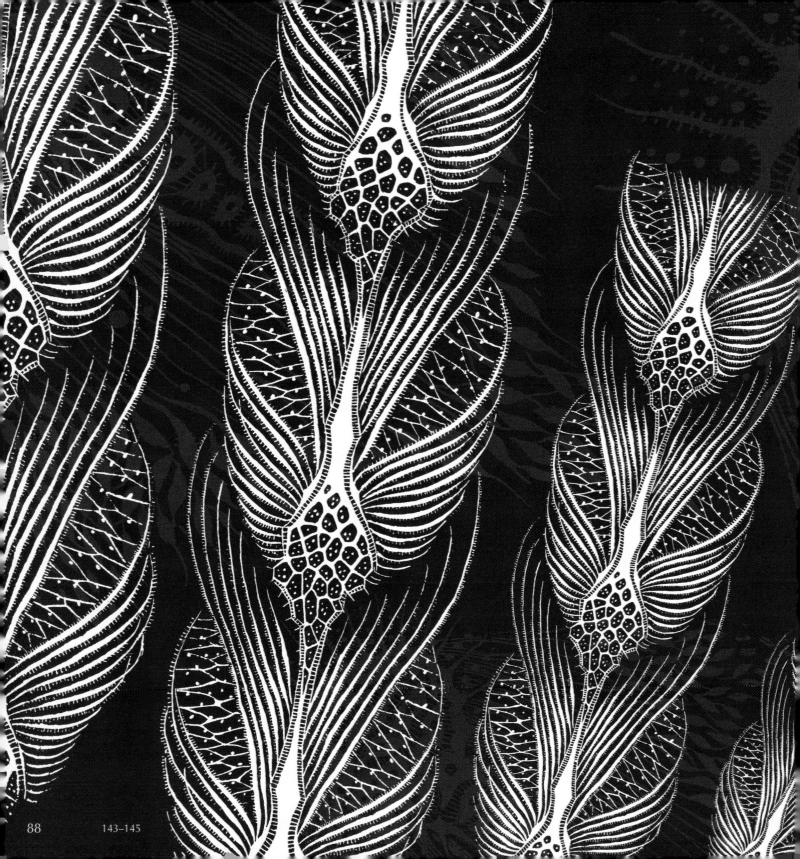

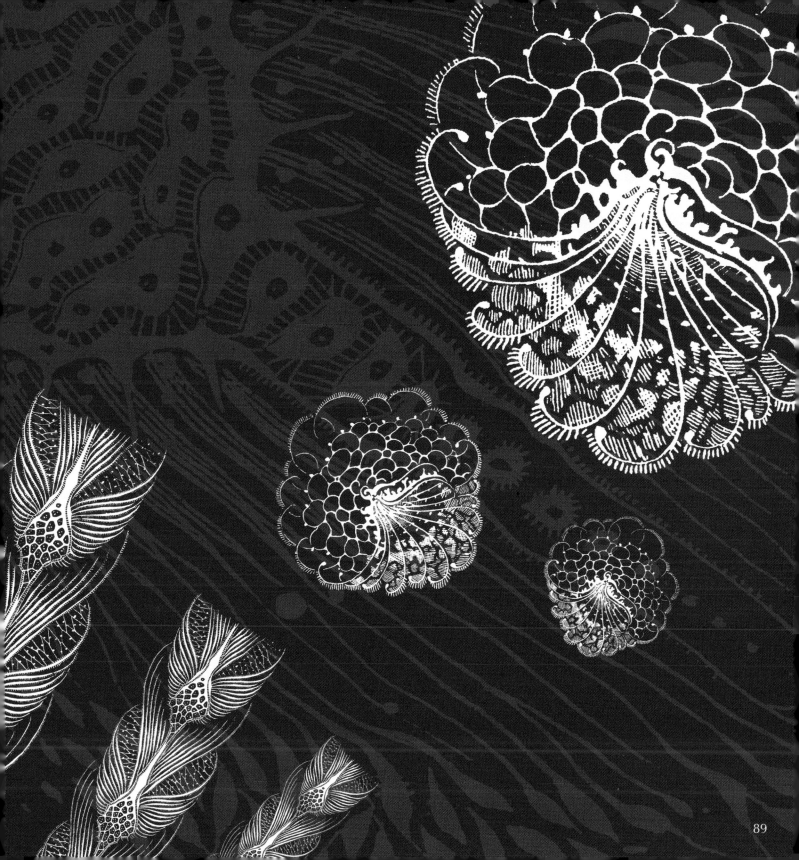

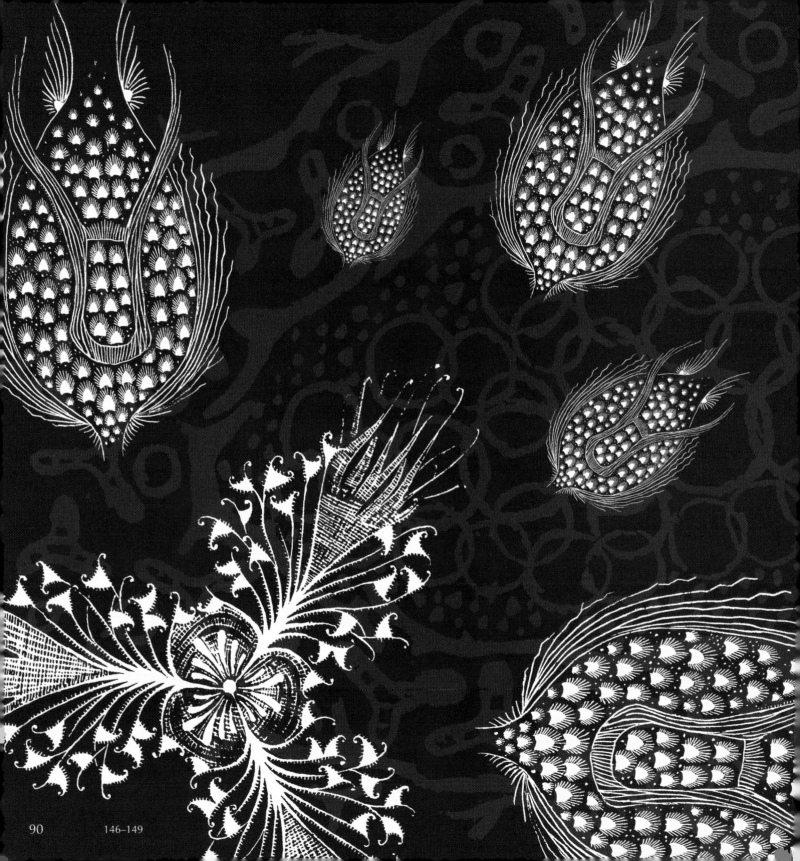

146–149

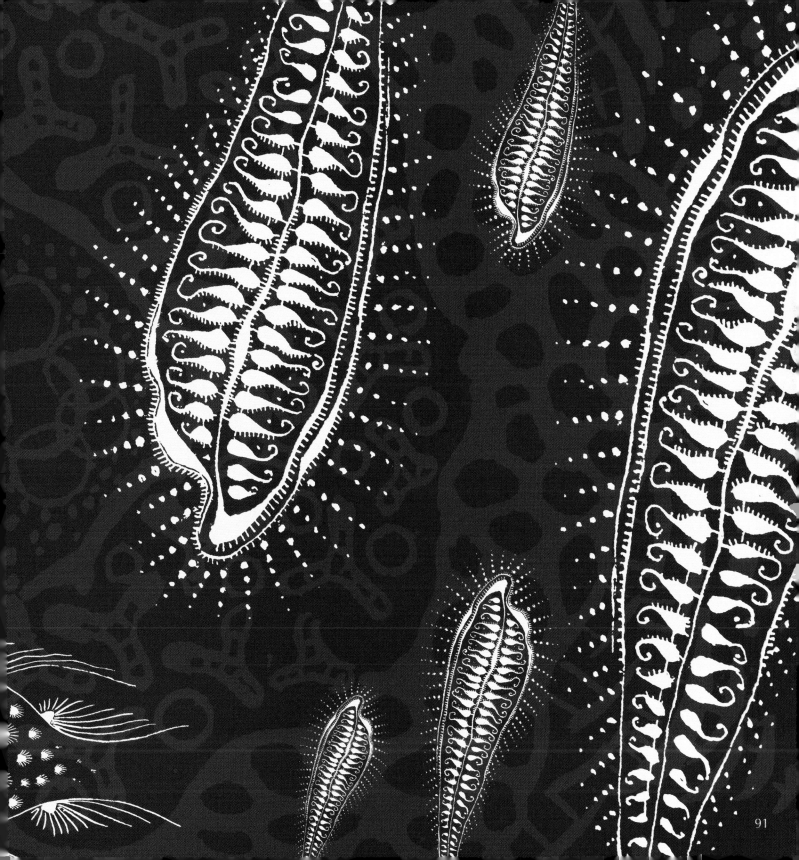

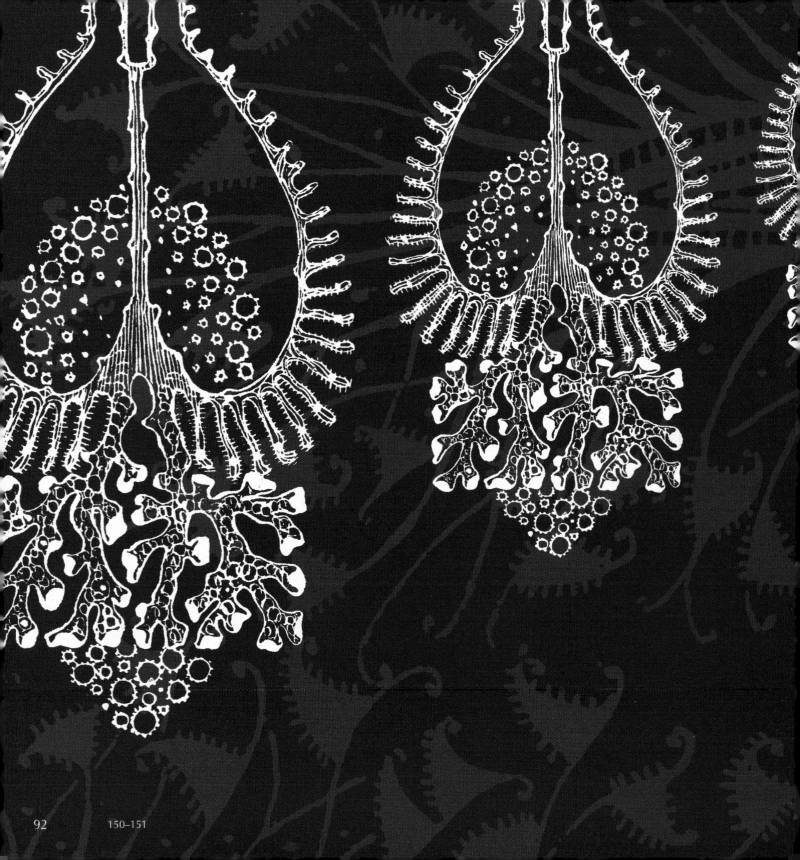

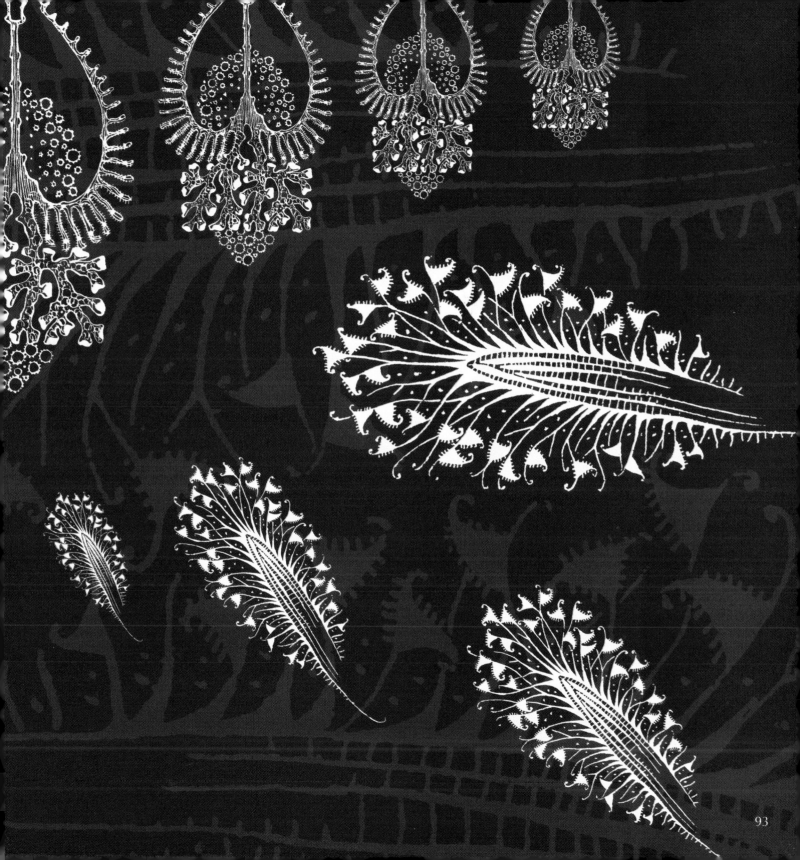

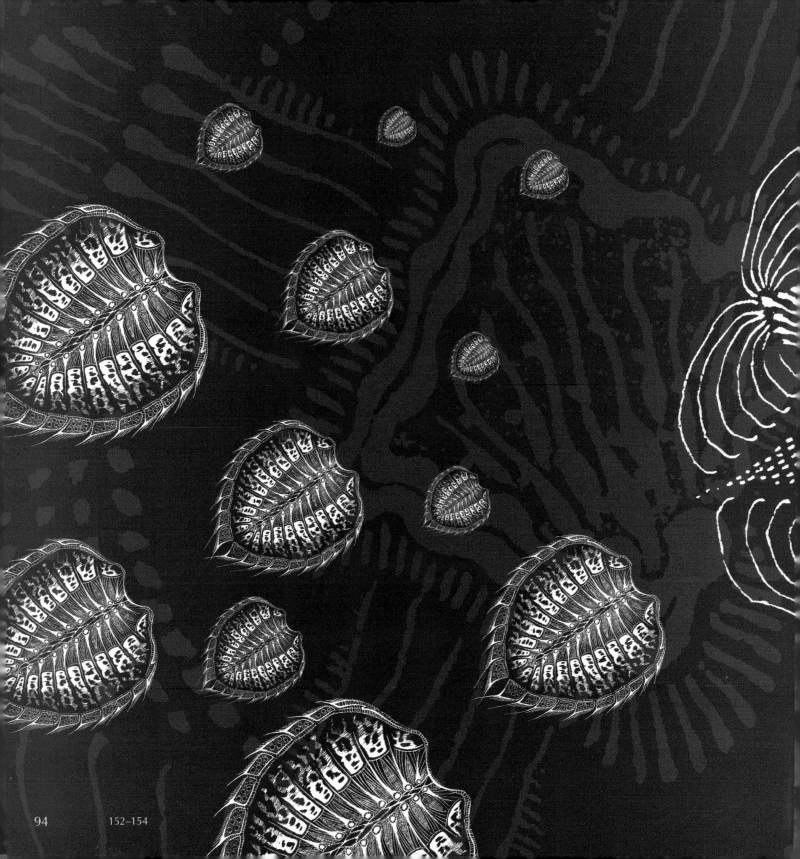

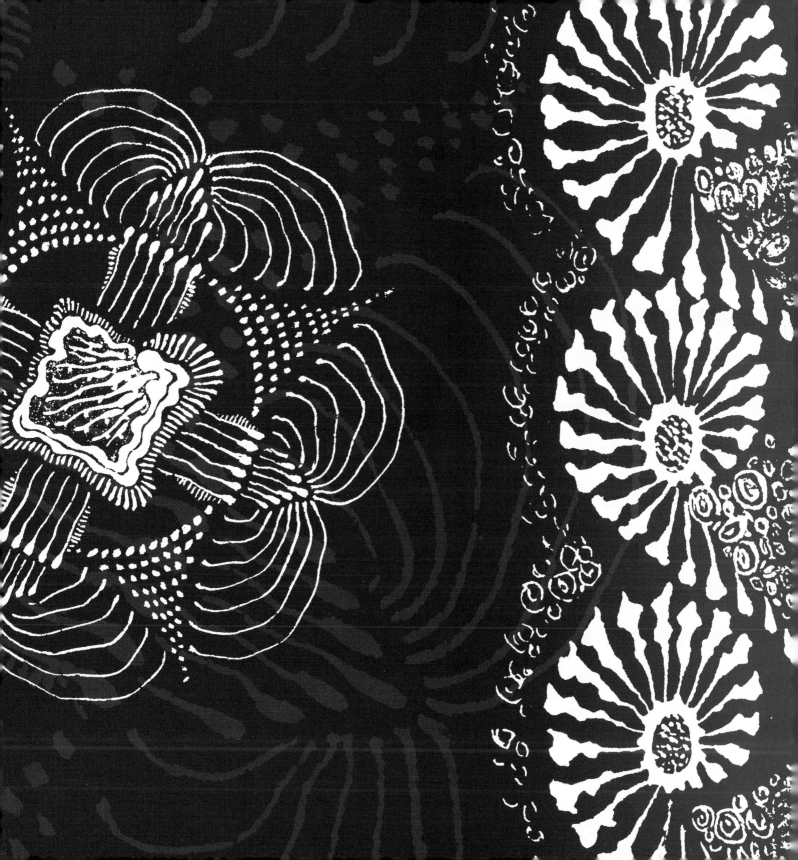